DISPLAY & ART HISTORY

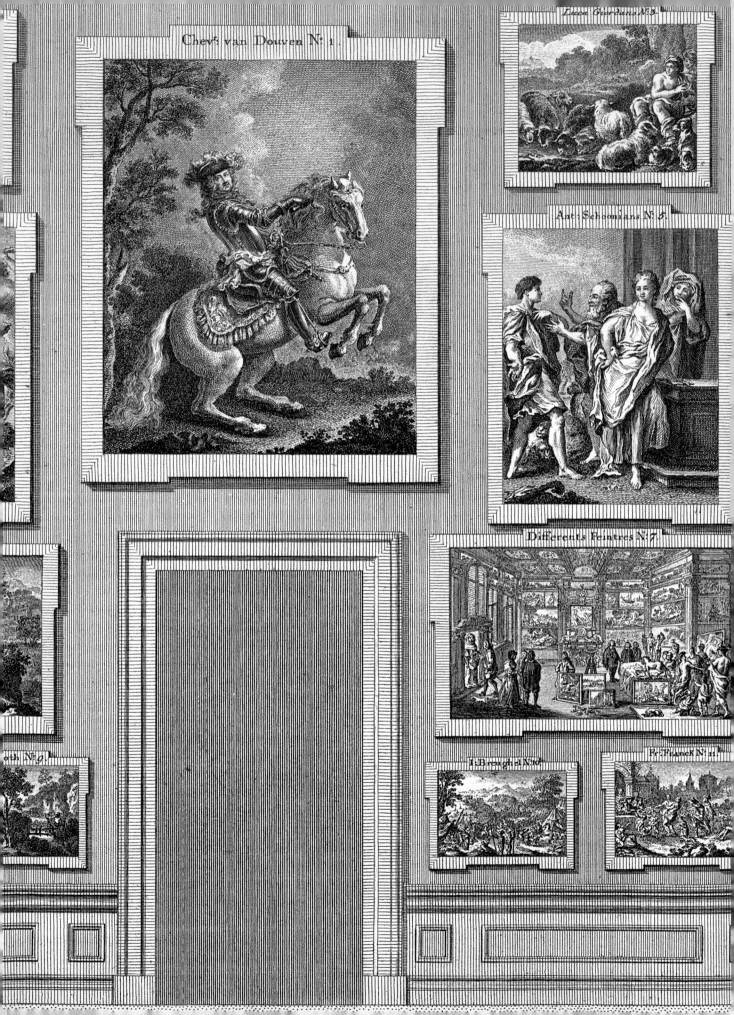

Chev: van Douven No. 1.

Lucca Giordano No. 3.

Ant: Schoonians No. 5.

Differents Peintres No. 7.

I. Breughel No. 10.

F. Franck No. 11.

DISPLAY & ART HISTORY

THE DÜSSELDORF GALLERY AND ITS CATALOGUE

Thomas W. Gaehtgens and Louis Marchesano

THE GETTY RESEARCH INSTITUTE

The Getty Research Institute Publications Program
Thomas W. Gaehtgens, *Director, Getty Research Institute*
Gail Feigenbaum, *Associate Director, Getty Research Institute*

Display and Art History:
The Düsseldorf Gallery and Its Catalogue

Edited by Michele Ciaccio
Designed by Picnic Design
Printed by Chromatic, Inc., Glendale, California

Thomas Gachtgens's essay "Making an Illustrated Catalogue
in the Enlightenment" was translated by Geoffrey Garrison.

This volume accompanies the exhibition *Display and Art
History: The Düsseldorf Gallery and Its Catalogue*, held
at the Getty Research Institute, 31 May–21 August 2011.

Published by the Getty Research Institute, Los Angeles
Getty Publications
Gregory M. Britton, *Publisher*
1200 Getty Center Drive, Suite 500
Los Angeles, California 90049-1682
www.gettypublications.org

15 14 13 12 11 5 4 3 2 1

Cover: First room, second facade of the Düsseldorf gallery
(detail), 1775. See pl. 1
Frontispiece: First room, first facade of the Düsseldorf gallery
(detail), 1776. Printer's proof for Nicolas de Pigage and Christian
von Mechel, *La galerie électorale de Dusseldorff . . .* (Basel, 1778),
pl. 1, 26 x 33.5 cm. Los Angeles, Getty Research Institute.

Library of Congress Cataloging-in-Publication Data

Gaehtgens, Thomas W., 1940–

 Display and art history : the Düsseldorf gallery and its
catalogue / Thomas W. Gaehtgens and Louis Marchesano.

 p. cm.

 Published to accompany an exhibition held at the Getty
Research Institute, May 31–Aug. 21, 2011.

 Includes bibliographical references.

 ISBN 978-1-60606-092-6

 1. Karl Theodor, Elector Palatine and Elector of Bavaria,
1724–1799—Art collections—Catalogs. 2. Pigage, Nicolas de,
1723–1796. Galerie électorale de Dusseldorff. 3. Painting—
Catalogs—History. 4. Art museums—Catalogs—History.
I. Marchesano, Louis. II. Getty Research Institute. III. Title.
IV. Title: Düsseldorf gallery and its catalogue.

 N2294.G34 2011

 759.94074'435534—dc22

 2011010765

CONTENTS

Dedicated to the memory of Jim Wood

PREFACE

It has already been two decades since Frances Haskell wrote a small but important book in which he analyzed the emergence of the illustrated art book in the eighteenth century. In his book, *The Painful Birth of the Art Book*, Italian and French works of the early eighteenth century served as the first examples of illustrated art history books to combine text and images. In this context belongs another publication that represents a milestone in the history of the museum catalogue: *La galerie électorale de Dusseldorff; ou, Catalogue raisonné et figuré de ses tableaux*, published by Nicolas de Pigage and Christian von Mechel in 1778.

The Getty Research Institute (GRI) holds more than five hundred drawings produced in preparation for this extensive and costly publishing enterprise. An additional 159 preparatory drawings are located in the Kupferstichkabinett in Basel. Examples of this unpublished material have now been exhibited for the first time at the GRI and described in their historical context in this publication. The substantial graphic collection allows us not only to reconstruct the logistic and technical process of making the catalogue but also to delineate the complex procedure of planning a traditional *Galeriewerk*. While the Düsseldorf catalogue distinguishes itself from these bound collections of prints, it draws upon that older tradition even as it opens up new perspectives into the art-historical treatment of a picture gallery. Both authors expand on these topics in this publication.

The project was only made possible thanks to many colleagues, to whom the authors are deeply grateful. Our thanks go to Kim Richter and Paris Spies-Gans for their assistance in researching, translating, editing, and organizing materials for the exhibition and the book. Special thanks go to Michele Ciaccio, our editor, Karina White, our exhibition designer, and Marci Boudreau, our book designer, for creating beautiful environments that showcase the Düsseldorf material. Giles Waterfield, Malcolm Baker, and Gail Feigenbaum read drafts of our chapters; we thank them for their insightful comments.

Martin Schuster, with his expertise in eighteenth-century picture galleries, provided crucial research support at the GRI and in Germany. Julia Armstrong-Totten offered vital advice on researching bankruptcy and public exhibitions. We also thank our colleagues in US and European institutions for providing images, information, or access to their collections: Astrid Bähr, Bettina Baumgärtel, Annika Baer, Alexandra Berend, Holm Bevers, Jörg Franzkowiak, Gillian Forester, Regina Hönerlage, Sigrid Kleinbongartz, Dawn Leach, Mark MacDonald, Christian Michel, Christian Müller, Mirjam Neumeister, Mariele Roters, Sabine Schroyen, Margaret Schutzer-Weissmann, and Angela Weihe.

Many individuals across the Getty were instrumental in realizing this project in record time. We thank Jennifer Alcoset, Jobe Benjamin, Peter Bonfitto, Beth Brett, Lauren Edson, Susan Edwards, Albrecht Gumlich, Alicia Houtrouw, John Kiffe, Melanie Lazar, Irene Lotspeich-Phillips, Teresa Mesquit, Marlyn Musicant, Isotta Poggi, Merritt Price, Sheila Prospero, Marcia Reed, Mary Reinsch Sackett, Scott Schaefer, Stephan Welch, Davina Wolter, and Kevin Young.

—*Thomas W. Gaehtgens and Louis Marchesano*

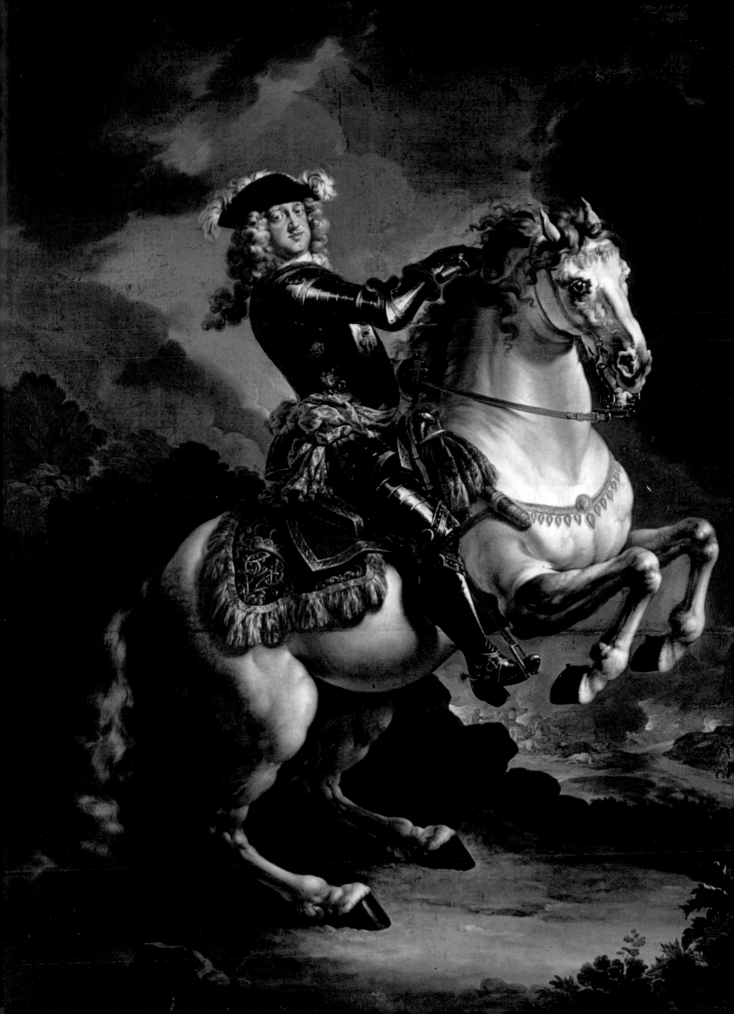

MAKING AN ILLUSTRATED CATALOGUE IN THE ENLIGHTENMENT

Thomas W. Gaehtgens

THE PICTURE GALLERY OF THE ELECTOR PALATINE JOHANN WILHELM II IN DÜSSELDORF

One of the most significant European picture galleries of the eighteenth century was located in Düsseldorf. Created by the elector Palatine, Johann Wilhelm II von der Pfalz (1658–1716) (fig. 1), the collection comprised around four hundred paintings, forty-six of which were by Peter Paul Rubens. This collection ended up in Munich in 1805 through inheritance and today forms a considerable part of the Alte Pinakothek.[1]

Johann Wilhelm II was one of the nine electors responsible for choosing the Holy Roman emperor. His father had inspired a passion for art in him. He employed Italian painters as well as his court painter Jan Frans Douven (1656–1727), who advised him on his purchases. His first wife, Maria Anna Josepha of Habsburg (1654–89), was the daughter of the German emperor. Through his second wife, Anna Maria Luisa de' Medici (1667–1743), the last of the Medicis, he had the best connections for acquiring Italian masterpieces. He was also able to get one of the most famous Dutch *fijnschilders* of the day, Adriaen van der Werff (1659–1722), to paint for him almost exclusively.[2]

For many princes, reorganizing their substantial collections was an essential part of their political self-image around 1700. Princely representation in the baroque period no longer meant simply displaying a wide variety of artistic treasures. It also had to convey the message that a prince knew how to take care of these objects for the common good and that he made them available for study. Following the age of housing *mirabilia*—art objects and curiosities—in seventeenth-century *Wunderkammern*, some princes attempted to order their treasures according to systematic, if not scientific, criteria. Johann Wilhelm II and his successors, as well as Augustus II the Strong in Dresden, were among those baroque rulers who combined their passion for collecting with an interest in employing the expertise of connoisseurs. These princes established a paradigm, which was emblematic of the transition from the baroque to the Enlightenment.

FIG. 1. *Jan Frans Douven (Dutch, 1656–1727).* Equestrian Portrait of Elector Palatine Johann Wilhelm II von der Pfalz, *1703, oil on canvas, 325 x 260 cm. Düsseldorf, Stiftung Museum Kunstpalast Düsseldorf. Photo: Stiftung Museum Kunstpalast Düsseldorf, Horst Kolberg.*

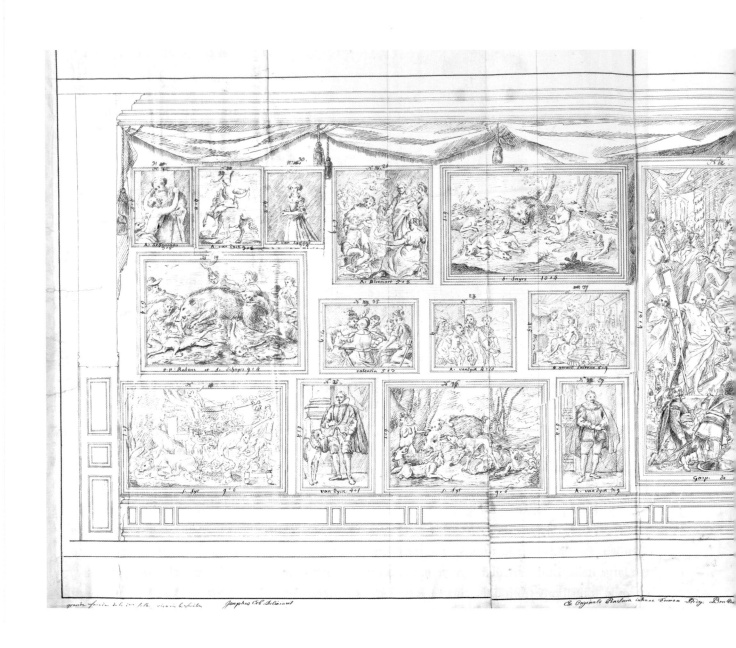

FIG. 7. *Joseph Erb (German, d. 1798), Joseph August Brulliot (German, 1739–1827), Georg Metellus (Dutch, d. 1787). First room, second facade of the Düsseldorf gallery, ca. 1770, graphite, red chalk, pen, and ink, 50.8 x ca. 177.8 cm. Los Angeles, Getty Research Institute.*

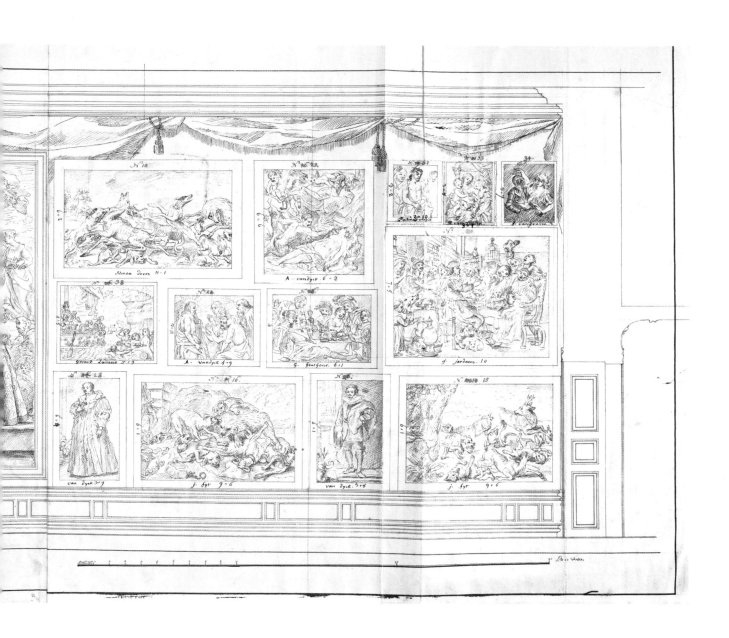

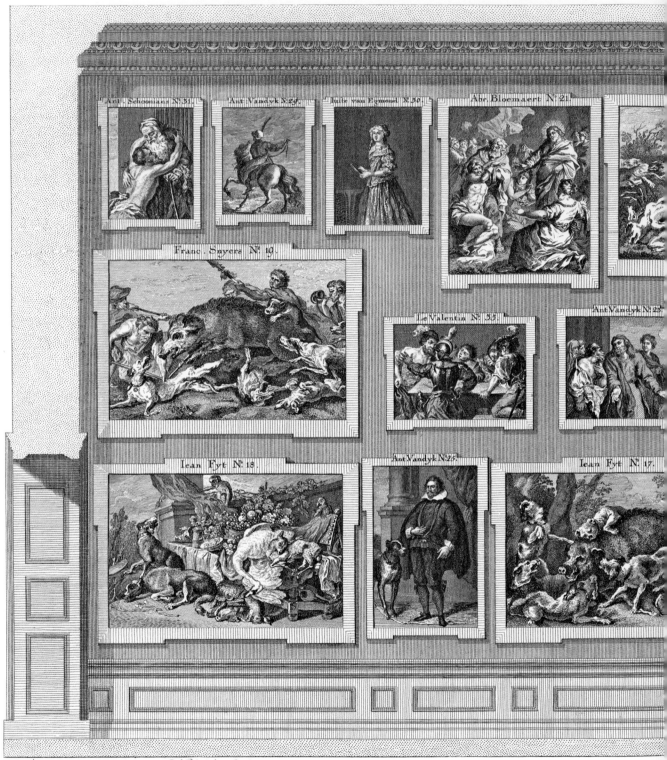

PLATE 1. *First room, second facade of the Düsseldorf gallery, 1775. Printer's proof for Nicolas de Pigage and Christian von Mechel,* La galerie électorale de Dusseldorff... *(Basel, 1778), plate 2: 26.9 x 33.2 cm; plate 3: 27.2 x 33.2 cm; plate 4: 26.9 x 33 cm. Los Angeles, Getty Research Institute.*

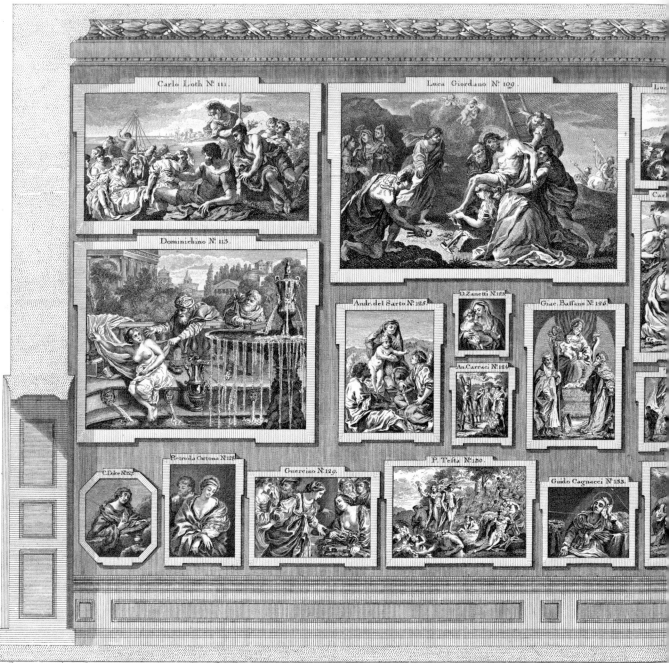

Gravé sous la Direction de Chr: de Mechel à Basle en 1776.

PLATE 2. *Third room, second facade of the Düsseldorf gallery, 1776. Printer's proof for Nicolas de Pigage and Christian von Mechel,* La galerie électorale de Dusseldorff… *(Basel, 1778), plates 10 and 11, each: 27.2 x 33.2 cm; plate 12: 26.8 x 33.2 cm. Los Angeles, Getty Research Institute.*

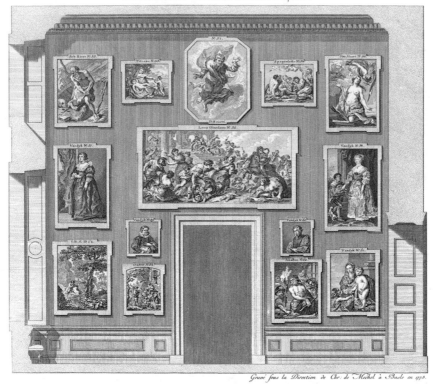

SECONDE SALLE Première Façade.

Gravé sous la Direction de Chr: de Mechel à Basle en 1778.

FIG. 8. *Second room, first facade of the Düsseldorf gallery, 1776. Printer's proof for Nicolas de Pigage and Christian von Mechel*, La galerie électorale de Dusseldorff... *(Basel, 1778), pl. 6, 21.7 x 32.3 cm. Los Angeles, Getty Research Institute.*

We do not know exactly how the paintings had been previously presented on the walls under Johann Wilhelm II. From the catalogue by Karsch, we can gather that the paintings had been hung densely, frame to frame. In the first room, there had been eighty paintings, which Krahe reduced to fifty. As a result, the paintings did not cover the walls entirely; instead, gaps were left between them, inviting the viewer to contemplate a painting's individual qualities. We might imagine that the gallery display in Düsseldorf around 1720 resembled to a certain extent the rooms in Pommersfelden, the palace of the elector of Mainz, as they are represented in engravings by Salomon Kleiner (1703–61) (fig. 9). In contrast to these earlier decorative displays, Krahe's arrangement can be read as a modern, already museological, presentation.

Within the individual schools, Krahe's hang followed the principle of symmetry. Each wall was viewed as a unity meant to convey to the viewer the total impression of the richness and diversity of that school of painting. The largest works were hung toward the top because they were still easily visible from below. Krahe divided the very long walls of the large hall into three sections, placing one of the largest paintings at the center.

A tour of the gallery via the reproductions of the walls in the 1778 catalogue reveals that the works' thematic coherence was taken into consideration; portraits or still lifes were hung as pendants. However, the majority of paintings in the gallery were history paintings, among which religious works dominated. In the cabinets of the palace—that is, in the elector's actual living spaces—the prince housed a greater number

of landscapes and still lifes. Large altar and devotional paintings were located in the gallery, making them available to visitors for the study of the history of painting. In this way, Krahe's new arrangement represented a professionalization of the ordering and presentation of this important baroque painting collection.

The visitor would also have been aware of the impact of devotional images. Although receptive to some enlightened ideas, Carl Theodor, as elector Palatine, was a strong supporter of the Catholic Church and followed the views of both his predecessors and his Jesuit advisers. Ideological and art-historical elements were therefore commingled in the mise-en-scène of the Düsseldorf gallery in the second half of the eighteenth century.

Parallel to his reorganization of the system of display, Krahe began putting together a *Galeriewerk*, a task that would occupy him for years and almost ruin him (see this volume, pp. 67–74). Krahe's plan was to publish albums of engravings representing the paintings in large format, in emulation of the engravings depicting the collection of Louis XIV, known as the *Cabinet du roi*, or those of the duc d'Orléans.[10] But the main inspiration for Krahe's project was the *Galeriewerk* of the Dresden picture gallery. Krahe received the rights to produce the engravings from the elector on 10 May 1768, albeit with the stipulation that he was to hand over any drawings produced for this purpose to the elector. These drawings were created by teachers at the Düsseldorf Academy.

Financially, the venture was extremely insecure. Krahe had to advance funds for all costs, and any hopes for a profit were based on the future sale of the prints. A major difficulty was the lack of engravers in Düsseldorf. Krahe was able to complete only four mezzotint prints. These were made by the engraver Johann Elias Haid (1737–1809) from Augsburg, but Krahe was dissatisfied with Haid's work. For this reason, he later turned to John Boydell (1719–1804) and Valentine Green (1739–1813) in London, who finally managed to engrave only a small part of the collection in the 1790s. Green exhibited these mezzotints, which were executed after copies painted by Johann Gerhard Huck (1759–1811), in an exhibition in London in 1793.

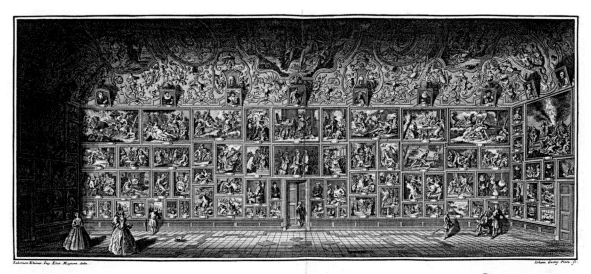

Vue interieure de la Gallerie du Coté des Appartements. Prospect der Gallerie gegen den Wohnzimer.

FIG. 9. *Johann Georg Pintz (German, 1697–1767/8), after Salomon Kleiner (German, 1703–61).* Vue interieure de la Gallerie du Coté des Appartements, *1728, etching, 22.9 x 24.5 cm. From Salomon Kleiner,* Representation au naturel des chateaux de Weissenstein au dessus de Pommersfeld…*[Augsburg: 1728], pl. 18. Los Angeles, Getty Research Institute.*

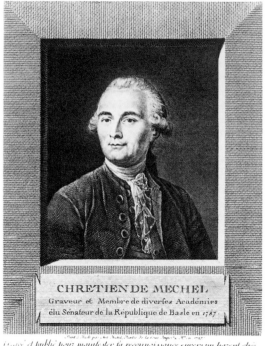

FIG. 10. *Anna Dorothea Lisiewska-Therbusch (German, 1721–82).* Portrait of Nicolas de Pigage, 1763, oil on canvas, 79 x 61 cm. *Düsseldorf, Stadtmuseum. Photo courtesy the Stadtmuseum, Düsseldorf.*

FIG. 11. *Johann Jakob von Mechel (Swiss, 1764–1816), after Anton Hickel (German, 1745–98).* Portrait of Christian von Mechel, *1787, engraving, 26.3 x 20.3 cm. Düsseldorf, Stadtmuseum. Photo courtesy Stadtmuseum, Düsseldorf.*

PIGAGE AND MECHEL'S CATALOGUE

Nicolas de Pigage (1723–96) (fig. 10), court architect to the elector Carl Theodor, entered the scene with a completely different concept.[11] His project was not limited to reproducing only the paintings in the picture gallery, for which Carl Theodor officially granted him permission in January 1770, but set out to represent all of the elector's palaces and gardens. For this task, Pigage brought in the help of the engraver Christian von Mechel (1737–1817) from Basel (fig. 11).[12] Of this far more expansive enterprise, not much was realized apart from the 1778 catalogue with the views of the picture gallery.

Pigage and Mechel's concept diverged fundamentally from that of their predecessor (fig. 12). Krahe's aim was to create the most exact reproduction of the individual paintings possible, so that the viewers could study the compositions and artistic styles. The publication of such a work by the director of the Düsseldorf Academy was intended to make the works available through precisely executed prints in a large format both to students of painting and also to a broader circle of those interested in the arts. Pigage and Mechel's publication is structured very differently from Krahe's. The first volume of their work is a catalogue text. The paintings are described with all their technical data and extensive commentaries. The second volume presents a plan and an elevation of the gallery building, followed by the allegorical paintings by Karsch in the staircase and finally the representation of all gallery walls with the paintings. Individual pictures can be identified, especially as their frames are labeled with the

LA GALERIE ELECTORALE DE DUSSELDORFF

OU

CATALOGUE RAISONNÉ ET FIGURÉ DE SES TABLEAUX

DANS LEQUEL ON DONNE

Une connoiffance exacte de cette fameufe Collection, & de fon local, par des defcriptions détaillées,
& par une fuite de 30. Planches, contenant 365. petites Eftampes redigées & gravées d'après ces mêmes Tableaux,
par CHRETIEN de MECHEL *Graveur de S. A. S. MONSEIGNEUR L'ÉLECTEUR PALATIN & Membre de plufieurs Académies.*

OUVRAGE COMPOSÉ DANS UN GOUT NOUVEAU,

par NICOLAS de PIGAGE *de l'Académie de S. Luc à Rome, Affocié Correfpondant de celle d'Architecture à Paris*
Premier Architecte Directeur général des Bâtimens & Jardins de S. A. S. É. P.

AVEC PRIVILEGE DE S. A. S. E. P.

A BASLE, chez CHRETIEN DE MECHEL & chez Mrs. les INSPECTEURS DES GALERIES ÉLECTORALES à DUSSELDORFF & à MANNHEIM.

MDCCLXXVIII.

FIG. 12. *Title page. Printer's proof for Nicolas de Pigage and Christian von Mechel,* La galerie électorale de Dusseldorff... *(Basel, 1778), 30.8 x 38.7 cm. Los Angeles, Getty Research Institute.*

names of the painters and catalogue numbers. Yet it is impossible to get an idea of the artistic character of the paintings themselves because of the small format of the engravings (see fig. 8, pls. 1, 2).

The two undertakings, by Krahe, on the one hand, and Pigage and Mechel, on the other, were therefore very distinct from each other. Krahe was not pleased by Pigage and Mechel's plan, and a dispute developed between them. Of course, this was in part because Krahe had to admit that his venture was a financial risk. It could hardly be expected that buyers would be found for both expensive publications. But the difficulties between the competing editors also focused on a very specific point. The paintings in Düsseldorf had to be copied first as drawings for the engravings, whether these were used as the basis for large-format plates or for small, miniature reproductions. Presumably, Krahe had already commissioned these drawings from his colleagues at the Düsseldorf Academy.

The elector, Carl Theodor, felt compelled to ease the conflict between the two parties. He forbade the two projects from being seen as competing with each other and ordered that the drawings commissioned by Krahe also be used for Pigage and Mechel's enterprise. But these measures by no means put an end to the hostilities, especially since Krahe continued with his own project.

But how did this early illustrated catalogue of paintings come about? What organizational and technical difficulties had to be overcome in order to produce this work? Major technical and financial obstacles had to be surmounted, especially as Carl Theodor, the gallery's owner, did not cover the enormous costs that publishing such a work brought with it. Although the prince generously relinquished the economic rights to the project, he did not help with its production.

THE PREPARATORY DRAWINGS AT THE GETTY RESEARCH INSTITUTE

Some insight into the ambiguities and complexities of this situation is made possible by a study of the drawings and prints acquired by the Getty Research Institute (GRI) in 1987. These materials have yet to be assessed in detail. It is clear that these works were connected to the planning of the famous illustrated catalogue of the Düsseldorf gallery that Pigage and Mechel published in 1778. The following is an attempt to situate the drawings and explain their function, though this is not a simple task.

The entire body of drawings and the proof prints originate from Mechel's workshop in Basel.[13] The collection consists of 149 drawings, mostly in pencil, in many cases squared and affixed to 43 loose sheets of paper. The GRI's drawings were once part of a group of an additional 159 drawings on 53 pages that is located at the Kupferstichkabinett in Basel. The

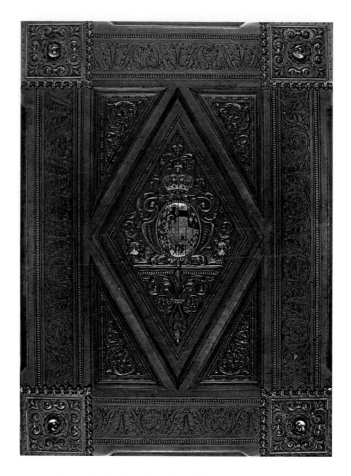

FIG. 13. *Cover of book of drawings after paintings in the Düsseldorf gallery. Leather binding, gold foil, red and green paint, possibly silver bosses, and amethyst cabochons, 57.8 x 41.9 x ca. 11.4 cm. Los Angeles, Getty Research Institute.*

GRI also holds a heavy volume, bound in leather in the second half of the nineteenth century and furnished with the coat of arms of the House of Palatinate-Neuburg (figs. 13, 14). It contains 359 beautiful drawings after the Düsseldorf paintings, mostly drawn in red chalk or watercolor in various formats and attached to the pages (figs. 15–22).

In addition, the GRI possesses a bound volume of drawings that show elevations of the Düsseldorf gallery walls as they appear in the catalogue by Pigage and Mechel (see fig. 7). In some places, pictures have been cut out and pasted elsewhere in the volume. The numbering of the paintings, which corresponds with Pigage and Mechel's catalogue numbers, has been changed in many places. Finally, the GRI holds a box of drawings that the engravers who executed the engravings for Pigage and Mechel used as templates (see figs. 25, 36). These drawings depict the paintings in the small formats employed for the final prints. Furthermore, the GRI holds multiple proof prints of all the engravings in various colors. This substantial assortment of drawings and prints, though initially confusing, is especially interesting because it gives us considerable evidence about the history of the planning of this highly elaborate and costly endeavor.

FIG. 14. *Spread showing drawings after paintings in the Düsseldorf gallery. Left: After Jan Boeckhorst (German, 1605–1668) and Peter Paul Rubens (Flemish, 1577–1640).* Resurrection of the Blessed *(cat. 279), red chalk, graphite, pen, and ink, 28.1 x 21.5 cm. Right: Peter Paul Rubens (Flemish, 1577–1640).* The Fall of the Rebel Angels *(cat. 257), red chalk, graphite, pen, and ink, 35.7 x 26 cm. Los Angeles, Getty Research Institute.*

Pigage and Mechel's catalogue of the Düsseldorf gallery reproduces in miniature all the paintings as they were arranged on the wall. Although the paintings had different frames, they were standardized in the prints to achieve a harmonious and unified appearance. Kleiner's prints of the pictures at Pommersfelden cannot be considered to represent a catalogue but a view of a chateau. Through the illustrations in Pigage and Mechel's publication, it becomes possible to imagine a tour through the rooms in the second half of the eighteenth century and to analyze the criteria for arranging the works of art in this gallery.

Pigage and Mechel initially had to finance the draftsmen who supplied the drawings on which the engravings were based. Since the elector did not permit the paintings to be transported to Mechel's workshop in Basel, the drawings were produced in Düsseldorf. These are the works that are preserved both at the GRI and at the Kupferstichkabinett in Basel. It is likely, however, that Pigage and Mechel did not shoulder the entire costs of the draftsmen. Rather, they made use of the drawings that had already been produced for Krahe's *Galeriewerk* enterprise. Krahe had employed his associates from the Düsseldorf Academy for this task. The same is true for the very precise, detailed red-chalk drawings in the leather-bound book, which were certainly useful as models for the small prints in Pigage and Mechel's catalogue, although they were not absolutely necessary. It seems reasonable to assume that they were intended for Krahe's *Galeriewerk*. The conflict between the two parties is

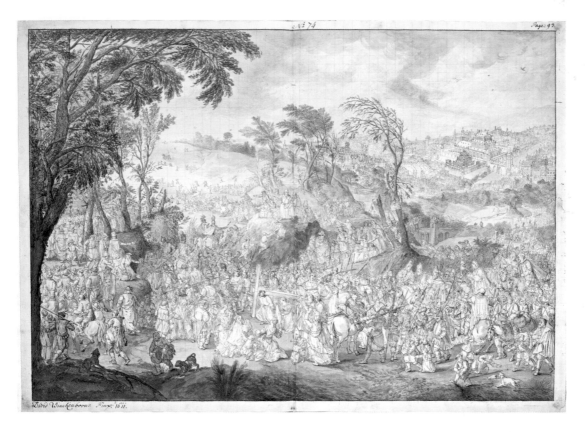

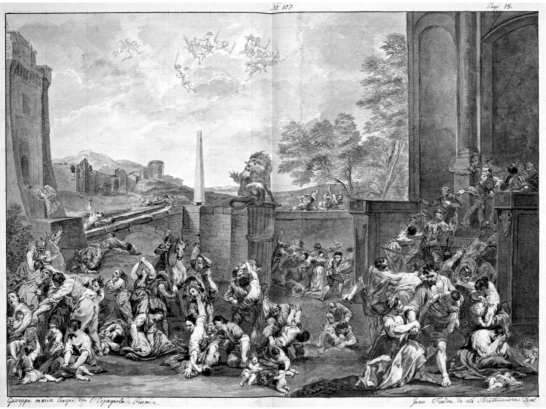

FIG. 15. *After David Vinckboons (Flemish, 1576–ca. 1632).* Christ Carrying the Cross *(cat. 74), ca. 1768–ca. 1775, wash, graphite, pen, and ink, 52.1 x 71.1 cm. Los Angeles, Getty Research Institute.*

FIG. 16. *Jean-Victor Frédou de la Bretonnière (French, b. 1735), after Giuseppe Maria Crespi (Bolognese, 1665–1747).* Massacre of the Innocents *(cat. 107), ca. 1768–ca. 1775, watercolor, graphite, pen, and ink, 48.6 x 66.7 cm. Los Angeles, Getty Research Institute.*

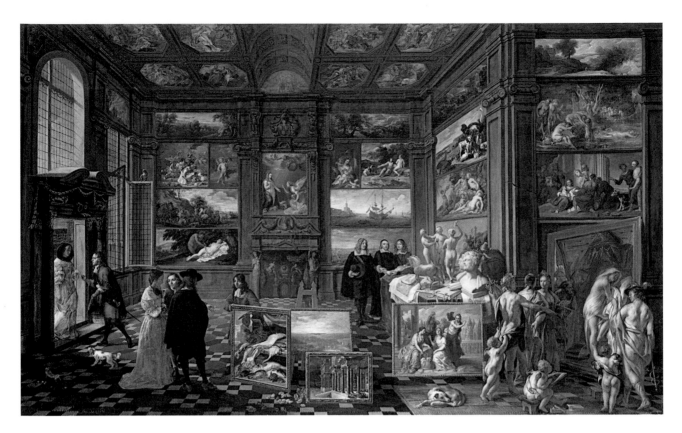

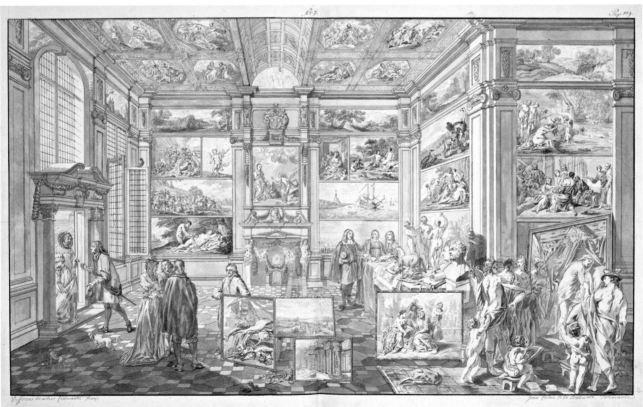

FIG. 17. *Wilhelm Schubert van Ehrenberg (Flemish, 1637–ca. 1676).* View of a Dealer's Picture Gallery, *1666, oil on canvas, 142.5 x 237 cm. Munich, Alte Pinakothek, Bayerische Staatsgemäldesammlungen. Photo: Bildarchiv Preussischer Kulturbesitz/Art Resource, NY.*

FIG. 18. *Jean-Victor Frédou de la Bretonnière (French, b. 1735), after Wilhelm Schubert van Ehrenberg (Flemish, 1637–ca. 1676).* View of a Dealer's Picture Gallery, *ca. 1768–ca. 1775, wash, graphite, pen, and ink, 47.6 x 71.8 cm. Los Angeles, Getty Research Institute.*

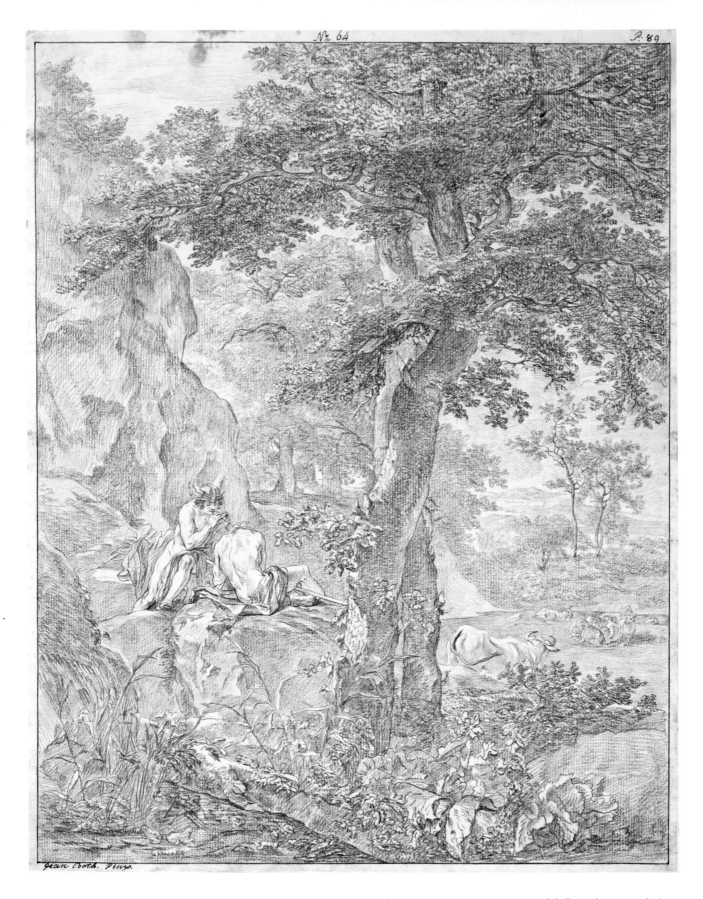

FIG. 19. *After Jan Both (Dutch, 1618–52).* Evening Landscape with Mercury and Argus *(cat. 64), ca. 1768–ca. 1775, red chalk, graphite, pen, and ink, 41.1 x 32.1 cm. Los Angeles, Getty Research Institute.*

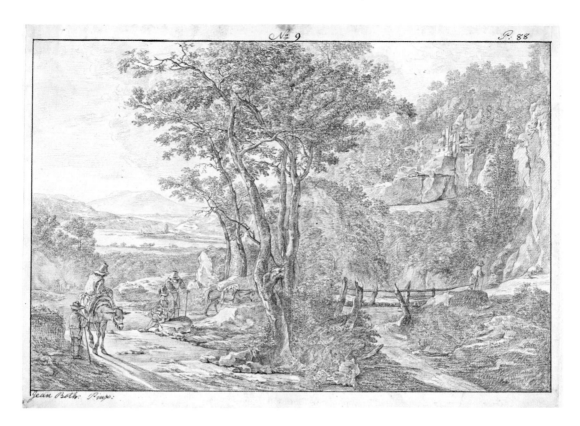

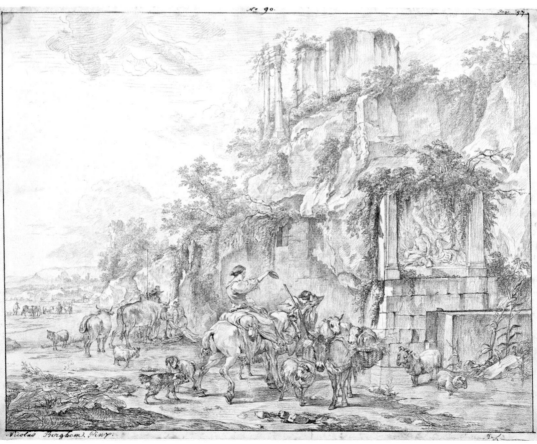

FIG. 20. *After Jan Both (Dutch, 1618–52).* Italian Landscape with Wood Bridge *(cat. 9), ca. 1768–ca. 1775, red chalk, graphite, pen, and ink, 30 x 40.9 cm. Los Angeles, Getty Research Institute.*

FIG. 21. *After Nicolaes Berchem the Elder (Dutch, 1620–83).* Rocky Landscape with Antique Ruins *(cat. 90), ca. 1768–ca. 1775, red chalk, graphite, pen, and ink, 32.5 x 40.9 cm. Los Angeles, Getty Research Institute.*

FIG. 22. *Jean-Victor Frédou de la Bretonnière (French, b. 1735), after Gerrit Dou (Dutch, 1613–75). The Quack Doctor (cat. 63), ca. 1768–ca. 1775, red chalk, graphite, pen, and ink, 63.5 x 48.6 cm. Los Angeles, Getty Research Institute.*

understandable, then, considering that Pigage and Mechel were allowed to use the drawings originally commissioned and possibly even paid for by Krahe for his album of prints. The dispute is even more understandable considering that Krahe never got these drawings back. They were kept in Basel, which is where the GRI acquired them.

We know the identities of most of the draftsmen involved, since they signed their drawings. In most cases nothing or very little has been recorded about their further activities. We know, however, that Jean-Victor Frédou de la Bretonnière (born 1735), Joseph August Brulliot (1739–1827), Georg Metellus (died 1787), Johann Gerhard Huck (1759–1811), and Joseph Erb (d. 1798), whose signatures can be found on the drawings, were professors at the recently established Düsseldorf Academy.

The number of artists involved grew when Mechel traveled to Paris in 1772 to take part in the auction of the collection of the former French foreign minister, the duc de Choiseul. He also used his stay there to enlist Parisian engravers. With the help of Johann Georg Wille (1715–1808), a draftsman and engraver residing in Paris, he succeeded in convincing three engravers to relocate to Basel: Balthasar Anton Duncker (1746–1807), Carl Gottlieb Guttenberg (1743–90), and J. Fr. Rousseau (born 1740). All three did move to Basel but were greatly disappointed with the working conditions. Rousseau immediately returned to Paris, while the two German engravers, who had envisioned work that could make their reputations, found themselves confronted with the task of producing miniature engravings. There was also no thought of giving them credit in the captions; the engravings appeared "sous la Direction de Chr. de Mechel," who presumably took no part whatsoever in the production of the engravings.[14]

FROM DRAWINGS TO PRINTS

The production of the prints for Pigage and Mechel's work was an extraordinarily complex and costly endeavor into which the surviving drawings offer particular insight. Whether they were produced for Krahe or for Pigage and Mechel, there was clearly an extensive supply of drawings available to the engravers in Basel. How did the process work?

One of the most famous paintings in the collection—*Saint John the Baptist in the Wilderness* by Daniele da Volterra, which was attributed to Raphael at the time—will serve as an example (fig. 23, right). The draftsmen first prepared drawings that captured the most important elements of the images in rough outline. Metellus squared this first drawing to simplify its transference onto another sheet of paper in red chalk, where all the details of the painted original would be depicted (fig. 24). Presumably, Metellus laid the first sheet on top of the second and then went over the outline of the male figure again with pressure in order to transfer exactly the contours of the figure for the red-chalk drawing. He was also responsible for drawing this second sheet, as the signature proves. Both are marked with the number 165, corresponding to the number in the text and on the illustrations of Pigage and Mechel's catalogue.

Several further steps needed to be taken in Mechel's workshop before the engravings were printed. Scale elevations of the walls, with miniature drawings representing the proper format and

proportion of the paintings, were sent to Basel (fig. 25). We know that Mechel was in Düsseldorf in 1770 in order to advance the catalogue project. It is possible that at this point he commissioned the drawings of the walls with the paintings, which were needed for the prints and are preserved at the GRI. They were executed by three draftsmen. As is evident from the signature at the bottom of the drawings, Erb drew the architectural framework, while Brulliot and Metellus sketched the small but true-to-scale renderings of the paintings. In several instances, the drawings of the paintings were cut out or pasted on to the sheet. It is not possible to determine whether on this occasion several paintings were also moved in the gallery, but it is a likely inference. The pages reproduce the paintings with frames in simplified form, provide the dimensions, and indicate the Pigage-Mechel catalogue numbers in red chalk.[15]

As a preparatory sketch for the wall engravings, a small red-chalk drawing was produced with the proportions of the painting (see fig. 23, upper left). These red-chalk drawings survive for some, but

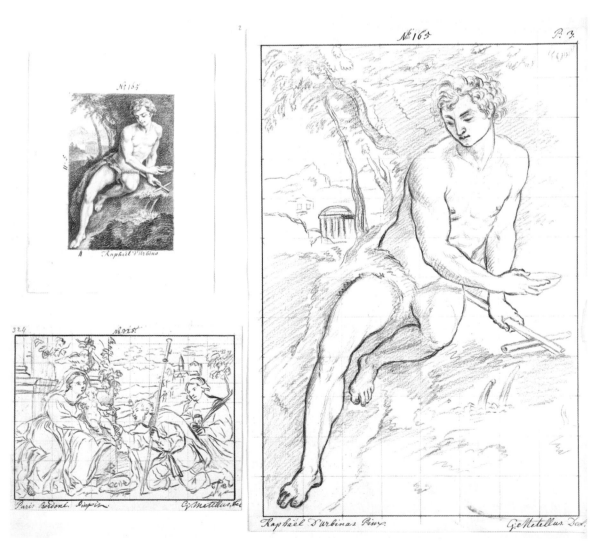

FIG. 23. *Right and upper left: After Daniele da Volterra (Italian, ca. 1509–66), formerly attributed to Raphael (Italian, 1483–1520).* Saint John the Baptist in the Wilderness *(cat. 165), ca. 1768–ca. 1775. Black chalk, graphite, and ink, 42.5 x 29.2 cm; red chalk, graphite, pen, and ink, 20.3 x 15.9 cm. Lower left: Georg Metellus (Dutch, d. 1787), after Jacopo Palma il vecchio (Italian, 1478–1528), formerly attributed to Paris Bordone (Italian, 1500–1571).* Saint Roch and Saint Madeleine Adoring the Infant Jesus *(cat. 324), ca. 1768–ca. 1775, black chalk, graphite, and ink, 15.9 x 20.3 cm. Los Angeles, Getty Research Institute.*

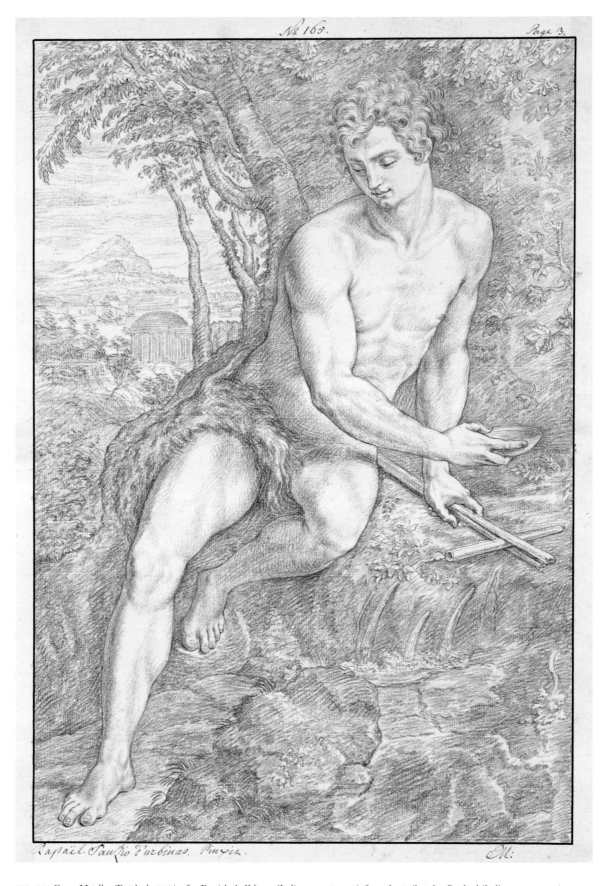

Rafaël Sanzio d'urbinas. Pinxit. M:

FIG. 24. *Georg Metellus (Dutch, d. 1787), after Daniele da Volterra (Italian, ca. 1509–66), formerly attributed to Raphael (Italian, 1483–1520). Saint John the Baptist in the Wilderness, ca. 1768–ca. 1775, red chalk, graphite, pen, and ink, 44.3 x 31 cm. Los Angeles, Getty Research Institute.*

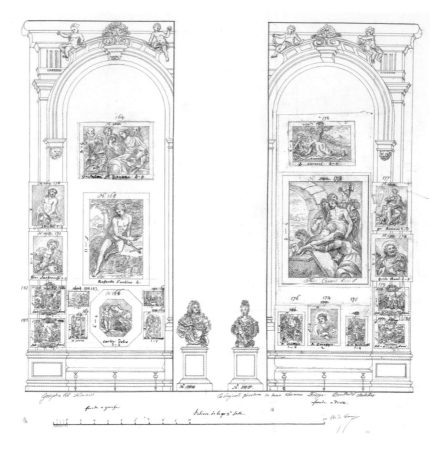

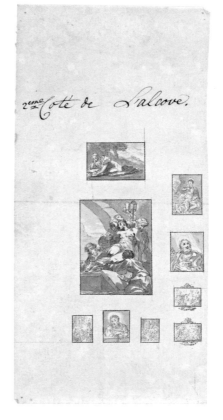

FIG. 25. *Joseph Erb (German, d. 1798), Joseph August Brulliot (German, 1739–1827), Georg Metellus (Dutch, d. 1787). Third room, small facades of window niche of the Düsseldorf gallery, ca. 1770, graphite, red chalk, pen, and ink, 49.1 x ca. 46 cm. Los Angeles, Getty Research Institute.*

FIG. 26. *Third room, small facades of window niche of the Düsseldorf gallery, ca. 1775–78, wash, pen, and ink, left: 21.8 x 11.2 cm, right 22 x 10.6 cm. Los Angeles, Getty Research Institute.*

TROISIEME SALLE. Les deux petites Façades dans l'avant corps.

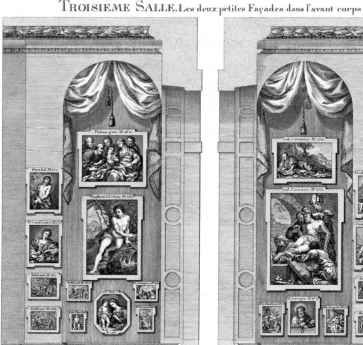
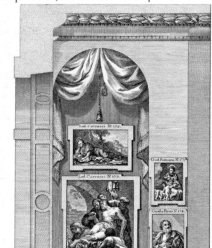

FIG. 27. *Third room, small facades of window niche of the Düsseldorf gallery, ca. 1775–78. Printer's proof for Nicolas de Pigage and Christian von Mechel,* La galerie électorale de Dusseldorff… *(Basel, 1778), pl. 14, 27.2 x 33.4 cm. Los Angeles, Getty Research Institute.*

not all, of the paintings. Apparently this step was abandoned following the first experiences with the work process, and the large red-chalk drawings were thereafter used as models for the miniatures on the wall in the engraving.

With that, the layout for the wall was essentially finished for the engravers. Yet there was another step before printing. The wall layout was executed in black-and-white washes on delicate, transparent paper (fig. 26). This page, with all the pictures on the wall, was apparently produced to determine the values, that is, the ink density for the print's overall impression. Only then could the production of the plates be carried out; unfortunately, these have not survived. The GRI possesses, however, printer's proofs for the pages, which show that Mechel and his employees experimented with various tones of black and brown (fig. 27).

The work of the engravers was extraordinarily laborious and could only have been carried out with magnifying glasses. As the most accurate sources, the large red-chalk drawings had to be consulted repeatedly. It is perhaps not surprising that, as previously mentioned, many engravers left Mechel's workshop as a consequence of the difficult and unsatisfactory working conditions.

Reception and Criticism of the Engravings

The illustrations were by no means generally acclaimed as a great event in publishing. In a certain sense the work has only now, in our century, achieved true fame. Contemporaries of Pigage and Mechel were rather skeptical. In their view, the paintings had been reproduced at such a small scale that their artistic merit could not be recognized. Even with a magnifying glass it is not possible to evaluate the painterly quality of the pictures. Anticipating this criticism, Pigage and Mechel remarked in the catalogue's preface that despite the great precision the engravers had sought, the illustrations were intended for identifying the artworks rather than for actually appreciating them. The prints convey very little about the painters' styles. On the contrary, the fine etchings reproduce all the paintings in the same, consistent style so that they almost give the impression of having originated from a single artist.

Despite some praise—and the acknowledgment that it was now possible to get an idea of the gallery—it was considered regrettable that the character of the masters could not be appreciated in the thumbnail etchings. *Der Teutsche Merkur* noted in 1778, for example, that "a minute print that an average thumb could cover can but give us an infinitely pale shadow of a masterpiece of the likes of G. Dow [Dou], for whose sake an entire room of the gallery has been named."[16]

The great innovation of depicting the arrangement of paintings on all gallery walls was essentially a continuation of the engravings by Salomon Kleiner, who had reproduced the walls of the Hubertusburg palace in Pommersfelden, together with the paintings covering them, as engravings in a similar format (see fig. 9). The reproductions of pictures in that work, however, were decidedly smaller and more cursory, so that Pigage and Mechel's engravings could be seen as a clear improvement over this precursor. The only precedence for illustrating a wall display in a print where individual paintings can be identified is the *Theatrum Artis Pictoriae*, which represents the picture gallery of the emperor in Vienna and was published between 1728 and 1733 by Anton von Prenner.[17] Another forerunner to the idea of representing all walls of a gallery was the catalogue of the Sanssouci picture gallery first published by Matthias Oesterreich in 1763. There, however, the pictures themselves were not represented; only the frames with numbers and information about the artists were indicated (fig. 28).[18]

The Pigage-Mechel project was, then, a compromise from the start. This can be seen in the final product. For as influential as the publication would become, Pigage's and Mechel's contemporaries already recognized its problems. When we view the volume of engravings from our vantage point today and consider it to be a revolutionary innovation, it is because we judge it retrospectively, in light of the history of the museum in the nineteenth and twentieth centuries and our familiarity with museum publications in which small, thumbnail-size illustrations continue to be used for identifying the individual works and not for studying them.

Those *Galeriewerke* published during the middle of the seventeenth century, prior to and also after Pigage and Mechel's work, were used precisely for the purpose assumed by the critics of the Düsseldorf catalogue: the large-format engraved copies were intended to evoke the unique artistic

FIG. 28. *Wall of the Sanssouci picture gallery, Potsdam. From Matthias Oesterreich and Burkhardt Göres*, Beschreibung der Königlichen Bildergalleri und des Kabinets im Sans-Souci *(Potsdam: Christian Friedrich Voß, 1764; Berlin: Generaldirektion der Stiftung Preussische Schlösser & Gärten Berlin-Brandenburg, 1996), [58–59].*

quality of a painter. By contrast, in Pigage and Mechel's publication, the function of these engravings was to illustrate the particular hang of the gallery. The catalogue sets out to present not only the arrangement of the collection according to schools and individual masters but also the modern approach of not hanging the paintings frame to frame, but rather allowing them to preserve their identity as works of art in the space. The volume of engravings therefore did not merely reproduce an existing display but went further than that. It promoted a new concept of staging paintings. The gallery had become a museum. The principle of hanging paintings in a gallery according to decorative and representational considerations was abandoned in favor of a system of order determined by the history and significance of the artworks themselves, resulting in a history of art. The engravings in Pigage and Mechel's catalogue represent this paradigmatic revision of the role of the gallery, which had occupied Krahe since 1763. The significance of this moment for the history of museums lies both in this new way of staging works in a gallery and in how the display and its constituent works were reproduced in the publication.

Who Was the Author of the Text?

It has generally been assumed that Pigage authored the catalogue texts because he signed the introduction. This, however, is highly unlikely, since such precise knowledge of painting and treatment of the individual pieces could hardly have been expected of such a busy architect. While there is no direct documentary proof, there are sufficient indicators that the text was a collaborative effort. Though Mechel must have played a major role in determining the content, he probably delegated the writing and editing. There is good reason to identify the real author of the text as Jean-Charles Laveaux (1749–1827) (fig. 29). The earliest mention of him as the main author is by Johann Christian Meusel, who in 1797 reported in his work *Das gelehrte Teutschland; oder, Lexikon der jetzt lebenden teutschen Schriftsteller* that Laveaux was heavily involved in the making of the "Gallerie de Dusseldorf."[19] It is indeed astonishing that references to Laveaux in older literature have not been pursued previously.

As a young teacher coming from France, Laveaux was an appropriate choice, given that French was the predominant language in eighteenth-century Europe and thus the obvious preference for the text. Laveaux, however, could have produced the commentaries only on the basis of material supplied to him by connoisseurs like Mechel or even Krahe. Careful reading of the Düsseldorf catalogue allows us to trace some of the scholarly sources used. It is especially revealing that the commentaries on the paintings articulate the intentions underlying the new display of the Düsseldorf gallery. Laveaux's role, then, seems to have been to pull all the information together and to present this material in a French text that was not too heavily laden with details comprehensible only to specialists.

Laveaux, who in later life would become known as an important linguist and would compose a seminal work on the grammar of the French language, lived an unusually eventful life in the final third of the eighteenth century and the first decades of the nineteenth century. Originally from Troyes, he moved to Basel in 1776 to teach French; there he apparently became acquainted with Mechel, who employed him to help with the catalogue. Following the completion of this work, he relocated to Stuttgart, to the Hohe Carlsschule, which he left again after a brief period. Political reasons appear to have played a role in his departure. Despite his republican convictions, he secured a position in Berlin, where he helped Frederick II compose his historical studies. A substantial work on the life of the Prussian king written by Laveaux would later be widely distributed in many languages. During the years of the French Revolution, he moved first to Strasbourg, then to Paris, where he became involved on the side of Mirabeau, whom he had presumably met in Berlin. As a member of the Girondists, he voted in favor of Louis XVI's death and spent a long time in prison during Robespierre's reign of terror. In subsequent years, he devoted himself to his scientific studies, particularly to the history of French grammar.

We have no documents that tell us exactly what Laveaux's role was in the preparation of *La galerie électorale de Dusseldorff*. Did he alone write the texts, or did he simply translate German originals into French? Did he have a hand in the content? Without additional sources, these questions cannot be answered precisely, though the internal evidence of the text allows us to speculate about the nature of Laveaux's involvement. For example, we have no documentary evidence that Laveaux took a trip to Düsseldorf to write descriptions of the original paintings. It is rather unlikely, though, that he composed the

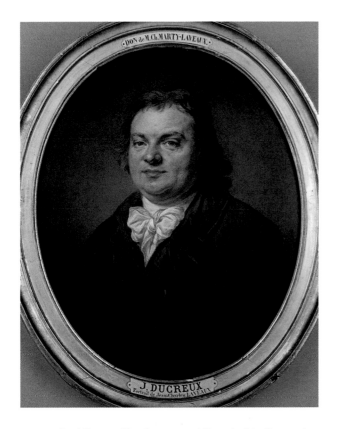

FIG. 29. *Joseph Ducreux (French, 1735–1802).* Portrait of the Grammarian Jean-Charles Laveaux, *ca. 1793, pastel, 72 x 60 cm. Paris, Musée du Louvre. Photo: Jean-Gilles Berizzi. ©Réunion des Musées Nationaux/Art Resource, NY.*

texts in Basel with nothing more than the aid of the drawings in Mechel's possession. Descriptions of colors in individual paintings, even if they do not appear throughout, support the assumption that Laveaux traveled to Düsseldorf. Closer examination of the commentaries on the paintings reveals a distinct uniformity in their method of analysis of the works. It therefore seems very improbable that multiple authors wrote them. Certainly, since Pigage's preface described the guidelines of the commentaries, we can assume that the preface and commentaries stem from the same author. And presumably the fundamental principles for the composition of all the texts were agreed upon by the author with Pigage and Mechel.

One of the writer's central aims was to interpret the intricate engravings for the reader. In the reproductions, some of which are only thumbnail-size, the subjects are often not even recognizable, especially in scenes with many figures. The texts therefore concentrate on providing detailed descriptions of the subjects. Only occasionally do they add remarks about artistic particularities, and these are usually limited to general comments.

To understand the distinctive character of the texts, it is necessary to examine them more closely, and this must be done through a selected case study. Prior to Laveaux's descriptions, only the aforementioned accounts by Karsch and Colins were available for the Düsseldorf gallery. Both Karsch and Colins offered merely a list of pictures indicating the subjects and techniques. Detailed texts on the individual pictures, then, were a new invention. No other text describing in great depth the individual paintings in a gallery's collection existed at the time. However, the two-volume catalogue, published in 1778, was still far too large and unwieldy, as well as too expensive. Therefore, a new edition in a smaller, more manageable format, although without the engravings, was published in 1781, making the commentaries on the images accessible to an even broader public. Taken together, the two publications represent what amounts to a revolutionary step in the history of museums, museum publications, and the art book. The title of the work by Pigage and Mechel was still *La galerie électorale de Dusseldorff*, and only the subtitle explained what it was exactly: *Catalogue raisonné et figuré de ses tableaux.* An important further step toward creating the modern museum catalogue had been made.

LAVEAUX'S ART-HISTORICAL SOURCES

To compose the commentaries on the paintings, Laveaux could rely only on one earlier text, a museum guide for the Düsseldorf gallery that was fresh off the press when Laveaux began his work. This was the *Observations raisonnées sur l'art de la peinture appliquées, sur les tableaux de la gallerie électorale de Dusseldorff suivies de quelques remarques, aussi instructives qu'agréables aux amateurs des beaux arts* by Jean-Victor Frédou de la Bretonnière, one of the aforementioned professors at the Düsseldorf Academy, who was responsible for a large portion of the best drawings in the leather-bound book (fig. 30).[20] Published in 1776, the *Observations raisonnées* was a small volume, of which only a few copies were apparently printed. In his text, he guides a fictional visitor through the gallery in much the same way that Diderot does in his celebrated accounts of the Paris salon. Frédou's remarks on the paintings are not always particularly original. In general, he praised the works ebulliently, focusing particularly on those art-theoretical principles that had been commonplace since Roger de Piles: namely, drawing, color, and composition. This publication was created as a guidebook for the viewer, offering the remarks of a painter who acted as a vade mecum by indicating the works that, in his opinion, were most important. Since this book might well have served as a basis for Laveaux, we need to look closely at how the later, more thorough catalogue departed from the observations made by Frédou.

The comments made about the painting once attributed to Raphael, mentioned earlier with the discussion of the drawing process, offer a typical example (see fig. 24). Frédou begins by pointing out the special qualities of individual motifs in the picture to his companion: the head is *belle* and attests to *noblesse* and *caractère*, and it is precisely the beauty of the individual forms that distinguishes this great artist. There follows an observation that reveals that the author can be only a painter and an academic teacher: were the figure not holding the cross in its hand, then one might view the painting as a "superbe figure académique," resulting from a study of the nude made in the studio. As a professional and a teacher, the painter goes on to give constructive criticism: "ou il seroit a souhaiter cependant une autre épaule droite, & une autre cuisse gauche" (where one would like to see another

FIG. 30. *Title page of Jean-Victor Frédou de la Bretonnière,* Observations raisonnées sur l'art de la peinture appliquées…*(Düsseldorf: Zehnpfennig, 1776). Image provided by Stanford University Libraries.*

right shoulder and another left thigh).[21] This criticism from an academic teacher, that the left thigh appears to be too foreshortened, nonetheless, does not keep him from giving general praise for this beautiful painting attributed to Raphael.

Laveaux's text is completely different from Frédou's. It is objectively formulated and attempts, first of all, to present the picture to the reader so that one might imagine it for oneself without an illustration. The first lines immediately attest to a more language-oriented writer who knows how to describe the main motifs of the picture concretely. Laveaux's presentation of the picture's subject is especially successful because he follows the figure through its complex movement and encapsulates the characteristics of the pose in terms of a sense of calm and contemplation.

He forcefully concludes the description by declaring, "Cette position de figure est des plus belles, en même tem[p]s qu'elle exprime avec la plus grande vérité le repos du corps & de l'esprit. C'est une excellente étude d'Académie" (The position of the figure is most beautiful and expresses at the same time with great truth the calmness of the body and the spirit. It is an excellent academic study.).[22] In this way, Laveaux picks up a remark already found in Frédou but considers the equilibrium of the form by suggesting that the painting, being based on an extensive study of nature, successfully combines the calm of the body with its mental state.

In this example, we can see how Laveaux's commentary is characterized by a clear structure. Following a very adroit description of the image, which already traces the composition and the expression of the main figure, the writer emphasizes the peculiarity of the representation, thereby establishing the exceptional quality of the work. His assessment then culminates in the eulogistic characterization of Raphael as the *prince des peintres*, which Laveaux picks up from Frédou. The commentary's didactic approach shows how the author strives to guide the reader and gallery visitor by the hand and to open his eyes so that he can understand the painting. The commentary abstains from giving all the particulars about the life and influence of the painter and is unburdened by any cumbersome details about other works, so as to focus on the painting's visible attributes, which are comprehensible to an average person. This text, written from a pedagogic-explanatory standpoint, can, as it were, be understood by anybody.

With their didactic character, the commentaries in the catalogue are fundamentally distinct from, for example, Karl Heinrich von Heinecken's texts in the *Recueil d'estampes* of the gallery in Dresden, the first two volumes of which appeared in 1753 and 1757. These latter texts can be described instead as scientific discourse. They refer to other paintings by the artists, list references to writers who previously wrote about the paintings, and give the provenance of the works.[23] With quotations and footnotes, these commentaries were written for connoisseurs and professionals, and they attempt to establish a scientific, systematic foundation for the nascent discipline of art history. International connections, built up over years—especially with Pierre-Jean Mariette in Paris—supplied material for the dense commentaries that accompany the engravings in the *Recueil d'estampes*. They are addressed not to a broader audience but to specialists. Compared with this earlier work, Pigage and Mechel's catalogue, with its commentaries by Laveaux addressing another audience, emerges even more clearly as an innovation.

Pigage, Mechel, and Laveaux strove for comprehensibility and pursued the goal of making art accessible for an educated public. It was not meant to be restricted to a high social stratum. The catalogue appears to be less a product representing the grandeur of the court than a didactic endeavor. The publication of a new edition of the original texts in 1781, now in a smaller format and available at a lower price, may be seen as an entirely consistent continuation of this educational concept. In this sense, the engravings representing the walls could also have served as an overview of the schools of painting. Even if a reader had not had the opportunity to visit the gallery, the Düsseldorf catalogue alone could be used as an art-historical reference work.

LAVEAUX'S VISITS TO DÜSSELDORF

One question that arises is how Laveaux acquired the necessary knowledge to compose the text. It is not known whether this young man ever received an artistic education. Moreover, after his collaboration with Mechel, he never again published writings on art, as far as we know. It is therefore likely that he relied on directions, perhaps even written instructions, while drafting his text. But would written directions have been enough? A careful reading of the catalogue suggests that Laveaux must also have spent some time in Düsseldorf. Only by studying the actual paintings could he have formulated such detailed and exact descriptions, sometimes with references to colors. Given that *La galerie électorale de Dusseldorff* presents fundamental, conceptual aspects of the display, one can conjecture that Krahe himself guided Laveaux through the rooms. As mentioned earlier, Krahe conceptualized the walls according to a strict symmetry. The largest paintings were hung in the middle—the Rubens room with its many large paintings was an exception—while the sides were meant to correspond to a specific arrangement of the paintings. Krahe sought to pair paintings, even though they were sometimes hung far apart. He consistently implemented the basic principle of viewing a wall as a unit, where the paintings together conveyed a balanced overall impression.

Taking into account the catalogue numbers attributed to the paintings in the gallery, it is possible to reconstruct the system of ordering, since the pendants succeed one another. For example, on the large wall of paintings in the Italian room, the catalogue begins with the *Ascension* by Carlo Cignani (cat. 108) located at the center of the wall, then jumps to the left to the *Deposition* by Luca Giordano (cat. 109), and continues on to the right side with *The Raising of Lazarus* by the same painter (cat. 110; see pl. 2). If a visitor followed the text, he would have to turn again to the far upper left in order to behold *The Rescue of Agrippina* by Carl Loth (cat. 111) and once more return to the other side to view Tintoretto's *Annunciation* (cat. 112) on the far upper right. This impractical back-and-forth was even adopted for the new 1781 edition of the text, published as a pocket book to serve as a handy guide in the gallery.

That there were alternative approaches to such a sequence is, however, attested by Frédou's *Observations raisonnées*. The Düsseldorf professor consistently guides the visitor along the wall and points out the paintings that he regards as important, thus avoiding the back-and-forth movement. For the catalogue by Pigage and Mechel, its use in the gallery seems to have been less of a driving factor than the viewing of the volume's prints. Even then, the reader is constantly forced to leaf back and forth

between the pages in order to look at the left or right sides of the wall. From this, it would appear that the numbering in the catalogue could not have served as a guide to view the actual gallery in this order. Instead, it keeps together the paintings by one artist even if they are separated on the walls. This is an order that does not allow the viewer to stroll through the gallery along a linear path.

KRAHE'S DISPLAY

If one looks at the individual walls, one can identify guidelines that determined how Krahe hung paintings. An artistic and expert perspective was integrated into the symmetrical arrangement. The engravings in *La galerie électorale de Dusseldorff* are a visual source for understanding Krahe's concept of display. One glance at the main wall of the Flemish school in the first room would confuse a viewer today (see pl. 1). The order, rather than the mass of paintings, is what would today seem strange. Apparently, Krahe did not much value a thematic arrangement. As a result, the large-format Madonna painting is framed at the top by dramatic and gruesome scenes of animal fights. Interspersed are mythological scenes by Gérard de Lairesse. It would also seem odd to us that full-figure portraits alternate with dramatic animal scenes in the lowest register to either side of the central painting.

The explanation for this hang can be gleaned from the catalogue's text. In addition to the systematic order of pendants, Krahe seems to have been intent on calling attention to the painters' different styles. He therefore consciously paired contrasting artistic modes of expression. The painting at the center of the wall represents a balanced composition, one that is *grande et fière* (grand and noble), while the animal scenes framing it at the top express the *effet terrible* (savage effect) and the *feu et force de la composition* (fire and force of the composition). With Lairesse flanking the central painting in the middle, one can observe a *beauté de detail* (beauty of detail) and *graces* (gracefulness), while the catalogue text emphasizes the *vérité de la nature* (faithfulness to nature) in the paintings in the bottom register. As a director and teacher at the academy, Krahe evidently compared and contrasted the painterly modes of expression of the Flemish school in his arrangement of the gallery in order to introduce the viewer to its diversity. This didactic principle surely was intended to meet the needs of the students of the Düsseldorf Academy as well as visitors. Reading the commentaries of the Düsseldorf catalogue, we indeed see individual paintings exemplifying specific modes. Laveaux hardly could have come up with these descriptions by himself, and we can only infer that it was Krahe who introduced him to the principles of the hang.

Krahe's pedagogical hang can be observed in all rooms of the Düsseldorf gallery. As if to correspond with this, key words in the catalogue text signal how the contrasts were meant to be perceived. For instance, in the Italian room, Tintoretto's *Annunciation* (cat. 112) was hung above Annibale Carracci's *Massacre of the Innocents* (cat. 114, see pl. 2). Just as the display contrasted compositions exemplifying two distinct modes of expression, so the text of the catalogue plays upon the difference between a *composition simple et noble* (simple and noble composition) and another conveying horror and fear. The catalogue does not say much about Loth's paintings (cat. 111) on the other side of the wall but gives a detailed elaboration and high praise for Domenichino's artwork (cat. 113) below it. We learn how the body of

Susanna, shown emerging from the water, is depicted with the greatest finesse and detail. This observation, which is clearly one that stems from the observations of a painter, invites the viewer to compare Susanna's depiction with the one above representing Agrippina being rescued from the water.

Paintings showing the Madonna with child figured prominently in the collection of Johann Wilhelm II. It is telling how Krahe arranged some of these on the large wall of the Italian room. Two pairs of Madonna scenes frame the central painting by Cignani, one painting hanging above the other. To the left of this group hung the important work by Andrea del Sarto (cat. 121, fig. 31), which could be compared to the famous painting by Raphael from the collection of Canigiani (cat. 122, fig. 32). The two paintings of lesser importance, by Giulio Cesare Procaccini (cat. 119) and Parmigianino (cat. 120), were hung higher up and farther away from the viewer. The hang in room four is especially characteristic of Krahe's strategy of prompting the viewer to make

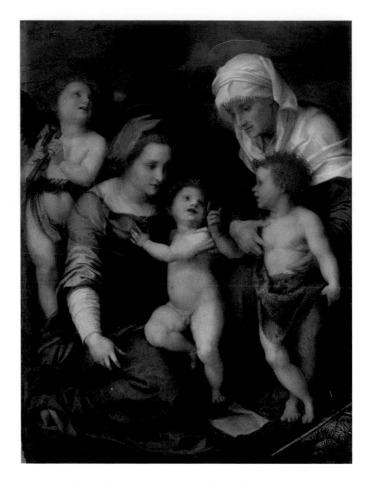

FIG. 31. *Andrea del Sarto (Italian, 1486–1530).* The Holy Family, *after 1514/15, oil on wood, 137.2 x 104.3 cm. Munich, Alte Pinakothek, Bayerische Staatsgemäldesammlungen. Photo: Bildarchiv Preussischer Kulturbesitz/Art Resource, NY.*

comparisons (fig. 33). The Passion of Christ cycle by Rembrandt (cat. 214–219, figs. 34a, b) and the much more extensive cycle of the Miracles of the Rosary by Van der Werff (cat. 221–237, figs. 35a, b) were hung above one another to illustrate the difference between a painterly work and a highly finished "fine-painting."

The catalogue registers a precise knowledge of the principles on which Krahe based his hang of the Düsseldorf gallery. Interestingly, his comments also include information about the paintings' histories and, in some cases, exact details about notations on the back of some paintings, as is the case with the work by Carlo Dolci (cat. 166). Another such case is the painting by Rubens and Jan Wildens representing the *Rape of the Daughters of Leucippus* (cat. 244, figs. 36, 37). Here the text of the catalogue mentions Winckelmann's reference to an antique relief, which is used to identify the subject of the painting. The entry does not, however, refer to the earlier identification of the painting in Wilhelm Heinse's descriptions of the paintings of the Düsseldorf gallery, published in 1776 in *Der Teutsche*

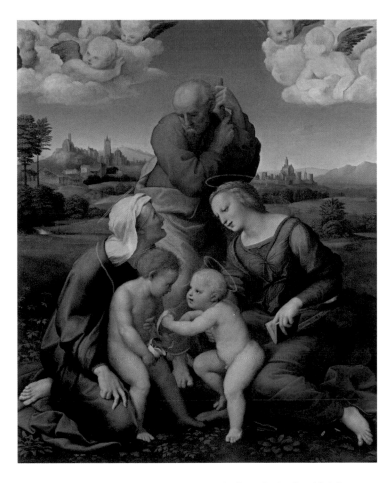

FIG. 32. *Raphael (Italian, 1483–1520).* The Holy Family with Saint Elizabeth and John the Baptist, *1505/6, oil on wood, 131 x 107 cm. Munich, Alte Pinakothek, Bayerische Staatsgemäldesammlungen. Photo: Bildarchiv Preussischer Kulturbesitz/Art Resource, NY.*

Merkur. Apparently written as a critical response to Frédou's guide, Heinse's preromantic descriptions, with their euphoric, literary evocations, contrast with Laveaux's style, which is characterized by an emphasis on facts rather than on personal impressions. In their differing interpretations of the art of Rubens, we can see a clear distinction between the attitude of an author of the French Enlightenment and one representing the German literary movement known as *Sturm und Drang.*

This distinctive feature becomes especially clear in the presentation of the paintings by Rubens, which were Johann Wilhelm II's special pride (figs. 38, 39). With its forty-six paintings by the Flemish artist, his gallery was one of the most prestigious collections of Rubens's work. The last room of the gallery in particular may be considered as an evocation of a renewed Catholicism. Here the dominating presence of a number of major altarpieces, such as *The Fall of the Rebel Angels,* now at the Alte Pinakothek (figs. 40, 41), demonstrated how the elector set out to represent himself as a defender of the Catholic Church, even within the gallery that constituted his secular environment. By assembling them in the space of the gallery, Johann Wilhelm II was at the same time acknowledging the outstanding artistic genius of the Flemish master. Krahe's display managed to combine these two elements. The predominance of the religious masterpieces is counterbalanced by smaller pictures, the two together characterizing the unique variety of Rubens's abilities.

All these details, together with the evident correspondence in both fact and principle between gallery display and textual description, strongly suggest that Laveaux conceived the descriptions in Düsseldorf, where he may have relied on the exact information and explanations offered by Krahe in person. As a result, Krahe's aesthetic concepts are present not only in the reproduction of the walls but also in the text of the catalogue. In addition, we can of course assume that Laveaux discussed each commentary with Mechel in Basel.

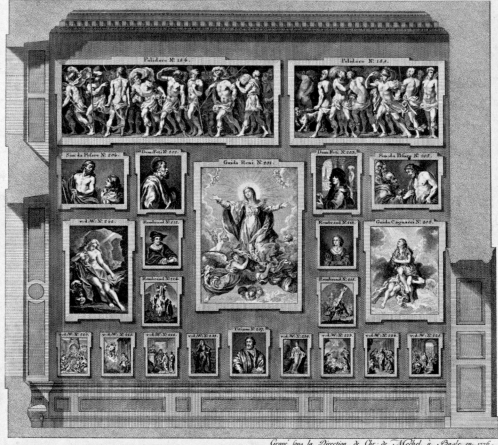

FIG. 33. *Fourth room, second facade of the Düsseldorf gallery, 1776. Printer's proof for Nicolas de Pigage and Christian von Mechel,* La galerie électorale de Dusseldorff… *(Basel, 1778), pl. 16. 27 x 33.2 cm. Los Angeles, Getty Research Institute.*

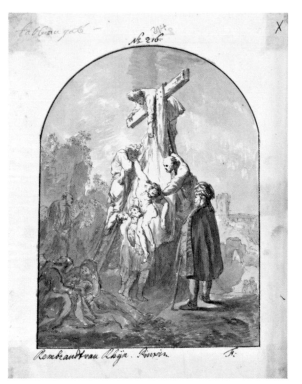

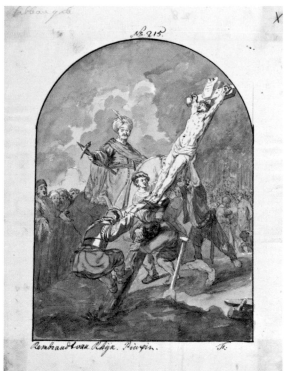

FIGS. 34a, b. *Jean-Victor Frédou de la Bretonnière (French, b. 1735), after Rembrandt van Rijn (Dutch, 1606–69) Left:* Deposition *(cat. 214); right:* Raising of the Cross *(cat. 215), ca. 1768–ca. 1775, wash, graphite, pen, and ink. Los Angeles, Getty Research Institute.*

FIGS. 35a, b. *Jean-Victor Frédou de la Bretonnière (French, b. 1735), after Adriaen van der Werff (Dutch, 1659–1722). Left:* The Visitation *(cat. 222); right:* Nativity *(cat. 223), ca. 1768–ca. 1775, red chalk, graphite, pen, and ink. Los Angeles, Getty Research Institute.*

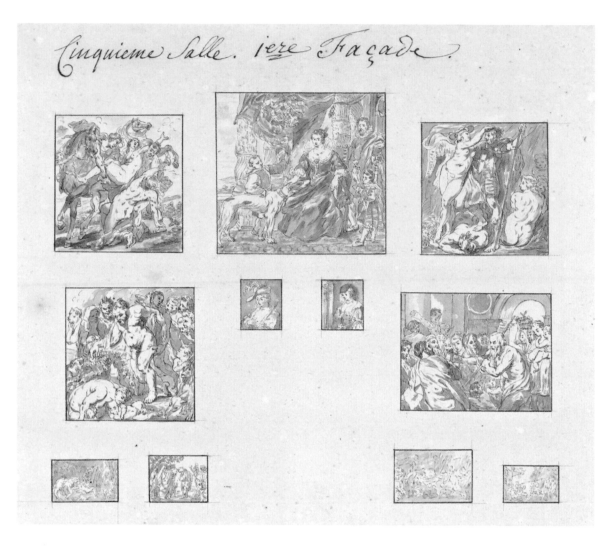

FIG. 36. *Fifth room, first facade of the Düsseldorf gallery, ca. 1775–78. Wash, pen, and ink, 20.9 x 24.9 cm. Los Angeles, Getty Research Institute.*

A WORK OF THE ENLIGHTENMENT

La galerie électorale de Dusseldorff might at first appear to be a straightforward endeavor. But the often-stressed originality of representing the walls of the gallery, enabling the viewer to take a virtual tour through the collection, can be properly understood only within a larger context. In both conception and production, the catalogue was in fact unusually complex. Fundamentally, it represented a compromise, or rather the result of a highly complex process of planning in a period of great change.[24] Its starting point was Krahe's attempt, inspired by the Dresden *Galeriewerk*, to publish prints of the most important paintings in the gallery. This project failed, since Krahe did not receive any financial support from the elector and was not himself in a position to bear the economic weight of such an undertaking. He never gave up this plan, however, and repeatedly attempted to realize it together with English partners.

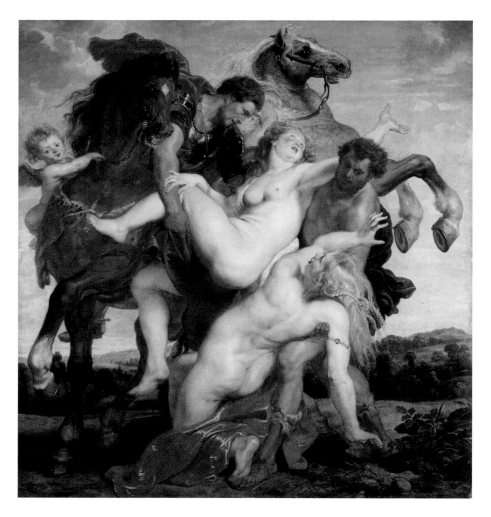

FIG. 37. *Peter Paul Rubens (Flemish, 1577–1640) and Jan Wildens (Flemish, 1585/6–1653).* Rape of the Daughters of Leucippus, *ca. 1618, oil on canvas, 224 x 210.5 cm. Munich, Alte Pinakothek, Bayerische Staatsgemäldesammlungen. Photo: Bildarchiv Preussischer Kulturbesitz/Art Resource, NY.*

The actual inspiration for realizing the catalogue was Carl Theodor's desire for prestige and his wish to promote the court's entire estate in volumes of engravings, of which the gallery was intended to take up only a small part. The catalogue would remain the most comprehensive and significant result of this ambitious initiative. Although the prestigious—one might even say political—aspect of the commission was not forgotten, it was certainly driven into the background. The art-historical consequences of visualizing the gallery as it was hung came to dominate the catalogue's production.

Yet Pigage and Mechel's venture can be properly understood only if it is reconstructed in its entire complexity and viewed within its historical context. From the volume of engravings intended to celebrate the prestige of the ruler and his court emerged a product dedicated to learning and education. That was by no means planned but, rather, resulted from the history of the work's production and the convictions and economic ambitions of the publishers, who were responding to the growing interest in

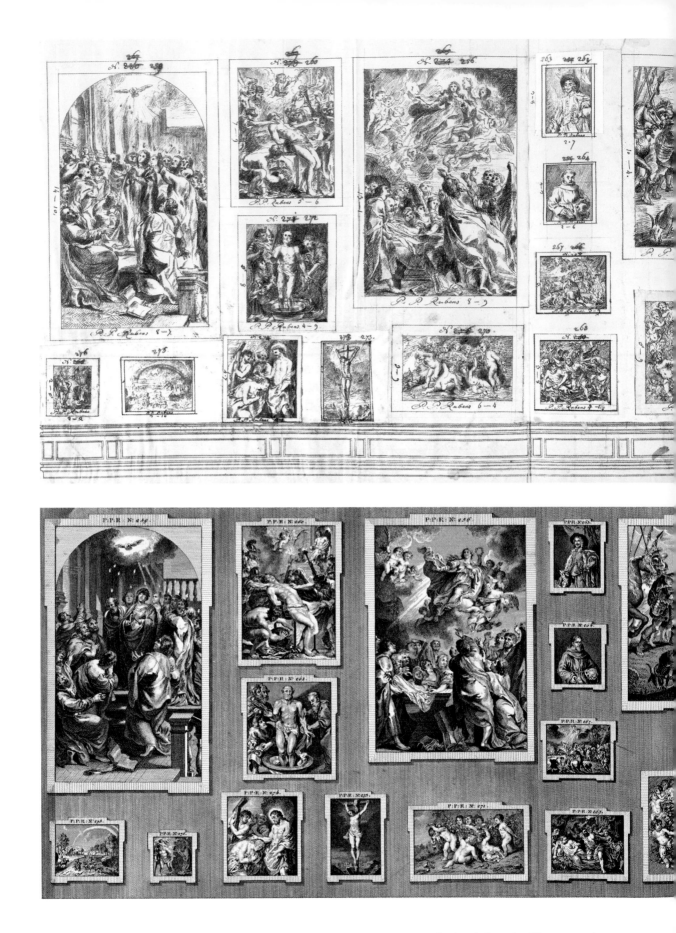

FIG. 38. *Joseph Erb (German, d. 1798), Joseph August Brulliot (German, 1739–1827), Georg Metellus (Dutch, d. 1787). Fifth room, second facade of the Düsseldorf gallery, ca. 1770, graphite, red chalk, pen and ink, 49.1 x ca. 122.5 cm. Los Angeles, Getty Research Institute.*

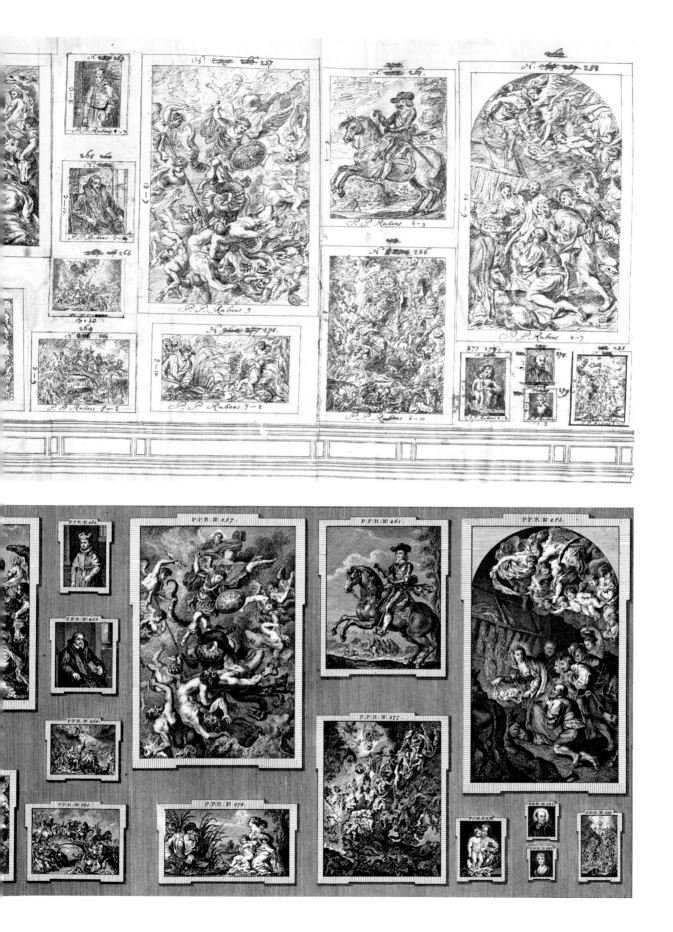

FIG. 39. *Fifth room, second facade of the Düsseldorf gallery, 1776. Printer's proof for Nicolas de Pigage and Christian von Mechel,* La galerie électorale de Dusseldorff *(Basel, 1778), plate 19: 26.9 x 33.4 cm; plate 20: 27.1 x 33.2 cm; plate 21: 26.9 x 33.2 cm. Los Angeles, Getty Research Institute.*

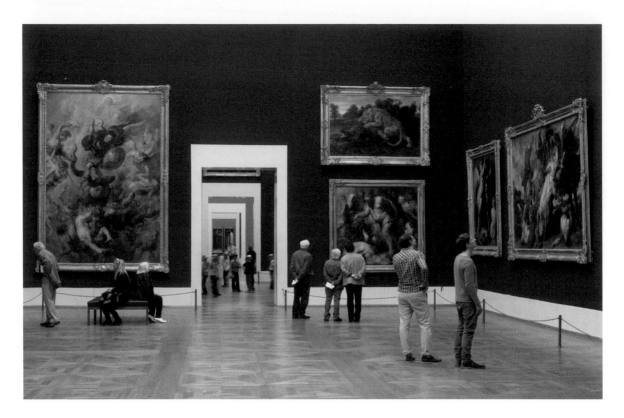

FIG. 40. *The Rubens Room, Alte Pinakothek, Munich, 2011. Photo: Bayerische Stadtsgemäldesammlung, Haydar Koyupinar.*

art among the bourgeoisie. The catalogue was no longer addressed solely, as had been the case with earlier publications, to the princely owner of the collection and those members of the nobility to whom he would present the work. For reasons unconnected with the elector's aims, the resulting publication was for a different readership. Pigage and Mechel followed their own economic interests and invested in a large print run, which is why it can be found in many libraries today. Since Carl Theodor had placed its production and the economic risk completely in the editors' hands, they sought a form that would find a wide range of buyers. Accordingly, costs were reduced and an overly luxurious design was eschewed. They geared the work toward the education of a broad circle of readers, who were given access to an understanding of art. In this sense, *La galerie électorale de Dusseldorff; ou, Catalogue raisonné et figuré de ses tableaux,* published by Pigage and Mechel with text composed by Laveaux, was very much a work of the Enlightenment.

Around the middle of the eighteenth century, initiatives to present princely collections in a novel way emerged in various locations. These efforts were interrupted by the Seven Years' War. During the 1760s, however, the newly appointed gallery directors in the most important centers of art were confronted with the question of how to shape the collections in new and modern ways. In 1764, Christian Ludwig von Hagedorn (1712–80) replaced Karl Heinrich von Heinecken in Dresden, while Luigi Lanzi (1732–1810) began to reconfigure the Uffizi galleries in Florence as early as 1775.

In each of these instances, a new paradigm was established. The paintings were ordered according to schools and, within schools, according to chronology. Of course this model could not be implemented everywhere in the same way. Not all princes maintained such extensive collections as in Dresden

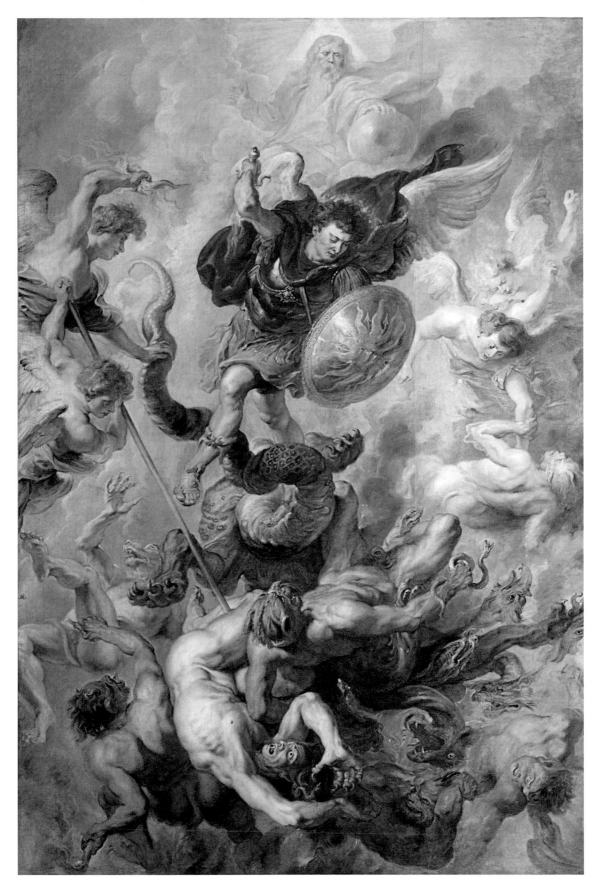

FIG. 41. *Peter Paul Rubens (Flemish, 1577–1640).* The Fall of the Rebel Angels, *1621/22, oil on canvas, 438 x 291.5 cm. Munich, Alte Pinakothek, Bayerische Staatsgemäldesammlungen. Photo: Bildarchiv Preussischer Kulturbesitz/Art Resource, NY.*

and Vienna. The tradition of hanging collections according to aesthetic principles, usually directed by painters who were commissioned to arrange the hang, was taken into a new direction. Experts who were knowledgeable about painting as well as the history of art now determined the order and the function of the galleries. Such galleries no longer served only as princely representations of magnificence or as exemplary collections for the use of painters. They were now also intended to further general education and therefore to be made available to the broader society outside the court.

The galleries in Dresden and Düsseldorf were designed with these intentions in mind, and they in turn influenced the display of the most extensive picture gallery, namely the collection of the emperor in Vienna. Having made a name for himself through the Düsseldorf catalogue, Mechel received the commission to orchestrate the move of the paintings from the Stallburg to the Upper Belvedere in 1778. There, he implemented the consistent division according to schools, thereby realizing the ordering that had been started but not fully carried out in Düsseldorf and Dresden. In

CATALOGUE

DES

TABLEAUX

DE LA

GALERIE IMPÉRIALE ET ROYALE

DE VIENNE,

composé par

CHRÉTIEN DE MECHEL,

MEMBRE DE DIVERSES ACADÉMIES,

d'après l'arrangement qu'il a fait de cette Galerie

en 1781.

Par Ordre

DE SA MAJESTÉ L'EMPEREUR.

Avec Privilège de Sa Majesté Impériale et Royale
pour le St. Empire Romain et les Pays héréditaires.

A BASLE CHEZ L'AUTEUR.

MDCCLXXXIV.

FIG. 42. *Title page of Christian von Mechel,* Catalogue des tableaux de la Galerie impériale et royale de Vienne *(Basel: Chez l'Auteur, 1784). Los Angeles, Getty Research Institute.*

Vienna, for the first time, visitors were presented with the "sichtbare Geschichte der Kunst" (visible history of art), as Mechel expressed it in his preface to the catalogue (figs. 42, 43).[25]

Underlying this modern reordering was the concept that the gallery should have a new function. Taken out of the context of princely representation, art, and especially painting, was to fulfill a pedagogical purpose. Aesthetic perception, developed from the academic tradition of the training of artists, was now paired with knowledge about the development of painting. This was the wish of the painters of the Académie royale de peinture et de sculpture in Paris, who demanded that royal collections be made accessible to them so that they could learn about the history of art from the eminent models. The ordering of selected masterpieces carried out at the Palais du Luxembourg thus followed the comparative principle. Paintings were hung as pendants so as to exhibit contrasting painterly effects in the treatment of drawing, color, and composition.

The principles that resulted from the professional needs of artists materialized in galleries around the middle of the eighteenth century. They were expanded through an approach to art that sought

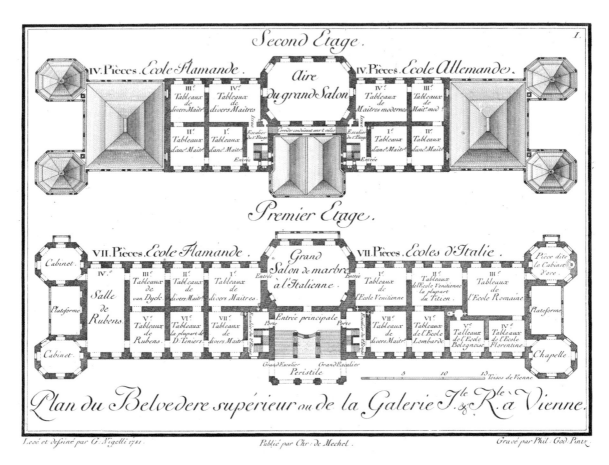

FIG. 43. *Philip Gottfried Pintz (German, fl. 1766–76). Floor plan of Belvedere picture gallery in Vienna. From Christian von Mechel,* Catalogue des tableaux de la galerie impériale et royale de Vienne *(Basel: Chez l'Auteur, 1784), pl. 1. Los Angeles, Getty Research Institute.*

to understand the works within their historical and cultural contexts. Johann Joachim Winckelmann (1717–68) had already proposed this systematic analysis of artworks as scientific objects in his writing published during this period. His method of observation paralleled that of scientific analysis of the period, as published, for example, by Georges-Louis Buffon (1707–88) in his *Histoire naturelle, générale et particulière* (1749–1803).

The Düsseldorf gallery played a significant role in the history of museums. From its inception as a princely collection and its relocation to a building solely built for housing the collection, the gallery was rearranged by Krahe so as to constitute a new professional display. In accordance with these new principles of display, the text and illustrations of the Düsseldorf catalogue presented its readers with what its authors called "un ouvrage composé dans un goût nouveau" (publication reflecting a new taste). Pigage and Mechel's *La galerie électorale de Dusseldorff* must therefore be considered as a turning point in which traditional baroque and modern enlightened concepts coincided. The display of the gallery in Düsseldorf still represents Krahe's artistic, didactic approach, whereas Pigage and Mechel's catalogue aims at providing scholarly art-historical information to a larger public. In the process, the princely gallery, accessible to interested visitors, becomes a public institution, the art museum.

ENDNOTES

1. Kornelia Möhlig, *Die Gemäldegalerie des Kurfürsten Johann Wilhelm von Pfalz-Neuburg (1658–1716) in Düsseldorf* (Cologne: Rüdigel Köppe, 1993); Susan Tipton, "'La passion mia per la pittura': Die Sammlungen des Kurfürsten Johann Wilhelm von der Pfalz (1658–1716) in Düsseldorf im Spiegel seiner Korrespondenz," *Münchner Jahrbuch der bildenden Kunst*, 3rd ser., 57 (2006): 71–332; Sabine Koch, "Die Düsseldorfer Gemäldegalerie," in Bénédicte Savoy, ed., *Tempel der Kunst: Die Geburt des öffentlichen Museums in Deutschland, 1701–1815* (Mainz: Verlag Philipp von Zabern, 2006), 87–115; Reinhold Baumstark, "Vergil und die erste öffentliche Gemäldegalerie in Deutschland," in *Denken in Bildern: 31 Positionen aus Kunst, Museum und Wissenschaft* (Berlin: Staatliche Museen zu Berlin, 2008), 8–15; Reinhold Baumstark, "Souverän gewunscht und formvollendet erhalten," in Christian von Mechel, *La galerie électorale de Dusseldorff: Die Gemäldegalerie des Kurfürsten Johann Wilhelm von der Pfalz in Düsseldorf* (Basel: Christian von Mechel, 1778; reprint, Munich: Hirmer, 2009), 7–27; Reinhold Baumstark, ed., *Kurfürst Johann Wilhelms Bilder*, 2 vols. (Munich: Hirmer, 2009); and Gustav Prümm, *Ein "Gewinn fürs ganze Leben": Die Düsseldorfer Gemäldegalerie des Kurfürsten Johann Wilhelm von der Pfalz* (Norderstedt: n.p., 2009).

2. Barbara Gaehtgens, *Adriaen van der Werff, 1659–1722* (Munich: Deutscher Kunstverlag, 1987).

3. Joshua Reynolds, *A Journey to Flanders and Holland, London 1781*, ed. Harry Mount (Cambridge: Cambridge Univ. Press, 1996), 112–36.

4. Gerhard Joseph Karsch, *Ausfuehrliche und gruendliche Specification derer vortrefflichen und unschaetzbaren Gemaehlden, welche in der Galerie der Churfuerstl. Residentz zu Duesseldorf in grosser Menge anzutreffen seyend* (Düsseldorf: Stahl, 1719); and Gerhard Joseph Karsch, *Detail des peintures du cabinet electorale de Dusseldorff* (ca. 1719).

5. Alfried Wieczorek, Hansjörg Probst, and Wieland Koenig, eds., *Lebenslust und Frömmigkeit: Kurfürst Carl Theodor (1724–1790) zwischen Barock und Aufklärung*, 2 vols., exh. cat. (Regensburg: Verlag Friedrich Pustet, 1999).

6. François-Louis Colins, *Catalogue des tableaux qui se trouvent dans les galleries du Palais de S.A.S.E. Palatine, a Dusseldorff* (ca. 1755). We are not well informed about Colins's work. It was an unfortunate decision to work over Raphael's Canigiani *Madonna* and to rub off and paint over the angels located in the corners; see Hubertus von Sonnenburg, *Raphael in der Alten Pinakothek* (Munich: Prestel, 1983), 13. For more on Colins, see Andrew McClellan, *Inventing the Louvre: Art, Politics, and the Origins of the Modern Museum in Eighteenth-Century Paris* (New York: Cambridge Univ. Press, 1994), 26; and François-Louis Colins, "Lettre a l'auteur du Mercure," *Mercure de France* 2 (April 1756): 170–74.

7. Krahe, the student of Pierre Subleyras (French, 1699–1749) and Marco Benefial (Italian, 1684–1764) in Rome, had only recently returned to the north from a longer stay in Italy. For several years, he had made purchases in Rome for the elector Palatine and had helped with the assemblage of a prints and drawings cabinet; see Wolfgang Wegner, *Kurfürst Carl Theodor von der Pfalz als Kunstsammler: Zur Entstehung und Gründungsgeschichte des Mannheimer Kupferstich- und Zeichnungskabinetts* (Mannheim: Gesellschaft der Freunde Mannheims und der Ehemaligen Kurpfalz [Mannheimer Altertumsverein von 1859], 1960).

8. Astrid Bähr, *Repräsentieren, Bewahren, Belehren: Galeriewerke (1660–1800); Von der Darstellung herrschaftlicher Gemäldesammlungen zum populären Bildband* (Hildesheim: Georg Olms, 2009), 301.

9. Christian von Mechel and Nicolas de Pigage, *La galerie électorale de Dusseldorff; ou, Catalogue raisonné et figuré de ses tableaux*, 2 vols. (Basel: Christian von Mechel, 1778).

10. Heidrun Rosenberg, "'. . . mindeste Connexion nicht habend': Zu den Galeriepublikationsprojekten von Wilhelm Lambert Krahe und Nicolas de Pigage," in *Nicolas de Pigage, 1723–1796: Architekt des Kurfürsten Carl Theodor* (Cologne: Wienand, 1996), 119–35; and Bähr, *Repräsentieren, Bewahren, Belehren*, 289–310. Cf. Louis Marchesano's essay in this volume.

11. *Nicolas de Pigage, 1723–1796.*

12. Lukas Heinrich Wüthrich, *Das Oeuvre des Kupferstechers Christian von Mechel: Vollständiges Verzeichnis der von ihm geschaffenen und verlegten grafischen Arbeiten*, 2 vols. (Basel: Helbing & Lichtenhahn, 1959).

13. Wüthrich, *Oeuvre des Kupferstechers Christian von Mechel*, 2:191–95.

14. Wüthrich, *Oeuvre des Kupferstechers Christian von Mechel*, 1:122–24.

15. To hypothesize that the drawings of the wall elevations were created several years earlier and that Krahe utilized them to conceptualize the new hang of the gallery in 1763 is less plausible. The drawings of the paintings that were pasted in seem to support this hypothesis. What speaks against it is the signature at the bottom, which states that the drawings capture in reduced size the walls as they were: "Josephus Erb deliniavit, Ex originali pinctura in hanc formam redege: Brulliot et Metellus" (Joseph Erb drafted it, Brulliot and Metellus reduced the original paintings into this form).

16. Wüthrich, *Oeuvre des Kupferstechers Christian von Mechel*, 1:127; Koch, "Düsseldorfer Gemäldegalerie," 105–7; and Bähr, *Repräsentieren, Bewahren, Belehren*, 324–27.

17. Bähr, *Repräsentieren, Bewahren, Belehren*, 150–66, 318.

18. Tobias Locker, "Die Bildergalerie von Sanssouci bei Potsdam," in Bénédicte Savoy, ed., *Tempel der Kunst: Die Geburt des öffentlichen Museums in Deutschland, 1701–1815* (Mainz: Verlag Philipp von Zabern, 2006), 231–34; Bähr, *Repräsentieren, Bewahren, Belehren*, 327; and *Die Bildergalerie in Sansoucci: Bauwerk, Sammlung, und Restaurierung* (Milan: Skira, 1996).

19. Georg Christoph Hamberger and Johann Georg Meusel, *Das gelehrte Teutschland; oder, Lexikon der jetzt lebenden teutschen Schriftsteller* (Lemgo: Meyerische Buchhandlung, 1797), 5:103. Only Wüthrich indicates Laveaux. Wüthrich, *Oeuvre des Kupferstechers Christian von Mechel*, 1:117, 125.

20. Jean-Victor Frédou de la Bretonnière, *Observations raisonnées sur l'art de la peinture appliquées, sur les tableaux de la gallerie électorale de Dusseldorff suivies de quelques remarques, aussi instructives qu'agréables aux amateurs des beaux arts* (Düsseldorf: Zehnpfennig, 1776).

21. Frédou de la Bretonnière, *Observations*, 49.

22. Mechel and Pigage, *La galerie électorale de Dusseldorff*, 1:43.

23. Katharina Pilz, "Die Gemäldegalerie in Dresden unter Berücksichtigung der Mengsschen Abgusssammlung," in Bénédicte Savoy, ed., *Tempel der Kunst: Die Geburt des öffentlichen Museums in Deutschland, 1701–1815* (Mainz: Verlag Philipp von Zabern, 2006), 157–59.

24. Bähr, *Repräsentieren, Bewahren, Belehren*, 327.

25. Christian von Mechel, *Verzeichniss der Gemälde der Kaiserlich Königlichen Bilder Gallerie in Wien* (Vienna: Christian von Mechel, 1783), xvi; the example illustrated here is the 1784 edition published in French. See also Debora J. Meijers, *Kunst als Natur: Die Habsburger Gemäldegalerie in Wien um 1780*, Schriften des Kunsthistorischen Museums 2 (Vienna: Skira, 1995).

Raphael Vrbin p. 12 Alta. 6 Lata. I. Treyen f.

2

THE DÜSSELDORF GALLERY AND THE END OF THE *GALERIEWERK* TRADITION

Louis Marchesano

In 1768, the elector Palatine, Carl Theodor (1724–99), granted the director of his gallery the rights to publish the rich collection of masterpieces that adorned the walls of the electoral gallery in Düsseldorf. This attempt to produce a suite of large-scale reproductive prints failed. Expecting that history could not repeat itself, twenty years later he granted similar rights to a successful London-based printmaker and publisher who, unfortunately, went bankrupt due to what the publisher's friend decried as the "vainglorious parade of the Düsseldorf business" (see this essay, p. 86). This indiscreet friend had no trouble pointing to the disequilibrium between the publisher's outsized ambitions and the costly reality of producing a comprehensive album of the collection, which required coordinating a network of artists in two distant cities and securing financing not only from banks and investors but also from a critical mass of subscribers who could support such an enterprise over a period of several years, if not decades.

This essay outlines these two failed attempts to produce a Düsseldorf *Galeriewerk* (literally, "gallery work"), that is, an album of reproductive prints, sometimes with descriptive text, that illustrates in whole or in part a collection of paintings displayed in galleries and cabinets, as well as salons, antechambers, foyers, and at times even in the chapels and bedrooms of collectors. In order to appreciate the historical substance of these failed *Galeriewerke*, this essay starts with an overview of the genre from 1660, when the first such volume was published in the Spanish Netherlands, until shortly after 1800, when the last of these bulky tomes stood out in postrevolutionary Paris as an anachronistic echo of the ancien régime's aristocratic values (figs. 1–3).

The first part of this essay surveys the patterns of patronage and production that characterized the *Galeriewerk* tradition. With the scholarship of Astrid Bähr, Evelina Borea, and Giles Waterfield in mind, I look at the ways in which the *Galeriewerke* served the needs of competing kings and princes who disseminated their good taste and majestic splendor through the reproductions of their paintings. Despite the collector's self-interest, more often than not the considerable financial responsibility for producing a lavishly illustrated volume fell upon the shoulders of either an ambitious court painter or

FIG. 1. *Jan van Troyen (Flemish, ca. 1610–after 1650), after Raphael (Italian, 1483–1520).* Saint Margaret, *1660, etching and engraving, 29 x 19 cm. From David Teniers the Younger,* Theatrum Pictorium…*(Brussels: Sumptibus auctoris [David Teniers]; Antwerp: Henricum Aertssens, 1660), pl. 2. Los Angeles, Getty Research Institute.*

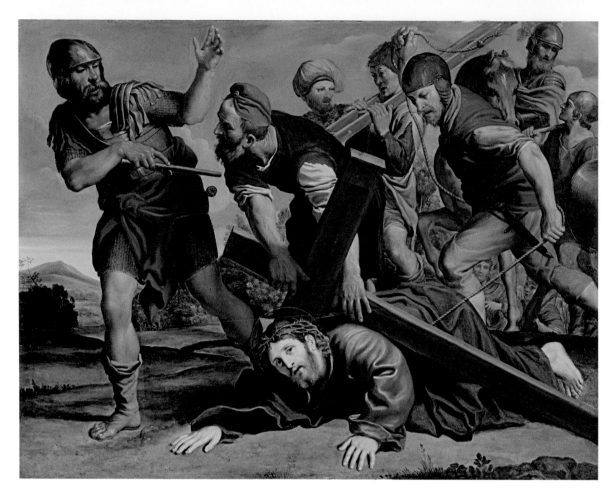

FIG. 2. *Domenichino (Italian, 1581–1641).* The Way to Cavalry, *ca. 1610, oil on copper, 53.7 x 67.6 cm. Los Angeles, J. Paul Getty Museum.*

a director of a collection. These characters, who are the main actors in this story, became editors and print publishers not necessarily because they had experience in such endeavors but because they had knowledge of the collections and access to patrons willing to grant them a *privilège* to copy and publish their paintings. The challenge to the publisher was to remain solvent while producing reproductive prints that in their size, accuracy, and production values reflected the quality and magnificence of the patron's original paintings.

The second part of this essay is devoted to the failed Düsseldorf *Galeriewerke*. The first of these was undertaken by the painter and gallery director Lambert Krahe (1712–90), who secured the rights to reproduce the elector's collection in 1768. In many ways, Krahe's ambitions and procedures were typical of the *Galeriewerke* publishers who enjoyed access to important collections and famous collectors. And just as typically, he was financially strained by the production of hundreds of highly finished preparatory drawings with which printmakers transposed the compositions and tonal values of paintings onto copperplates. With his financial resources depleted by the draftsmen he hired, all that Krahe could show for his efforts were those drawings and four mediocre prints.

To Krahe's chagrin, the splendid drawings made under his supervision were given by the elector to a publisher who produced *La galerie électorale de Dusseldorff; ou, Catalogue raisonné et figuré*

or "curators" of collections rather than the collectors themselves, whose primary role was to grant the coveted *privilège* to copy and publish their pictures. In the Spanish Netherlands, Leopold Wilhelm must have been naturally inclined to grant such a *privilège* to his court painter Teniers, who as overseer of the archduke's painting collection had already served his patron well with a new type of staged gallery picture (fig. 6). Commissioned by the archduke with specific recipients in mind, each gallery picture displayed a carefully selected group of paintings that addressed the tastes and collections of the intended recipient, all the while promoting the archduke's princely virtues of splendor, magnificence, and good taste. A case in point is the version sent to Madrid in the early 1650s. By exalting works then attributed to Titian's hand, including *Nymph and Shepherd* (Vienna, Kunsthistorisches Museum), *Diana and Callisto*, and the *Danaë* (location unknown), all in the upper reaches of the imaginary room, the gallery picture pointedly addresses the archduke's cousin, Phillip IV (1605–65), king of Spain, whose own treasure house of paintings had been enriched by Titian himself at the behest of Phillip IV and Leopold Wilhelm's common Hapsburg ancestor, Emperor Charles V (1500–1558). By means of these imaginary gallery views, Leopold not only reinforced the dynastic connections and aristocratic rivalry between

FIG. 5. *Théodorus van Kessel (Dutch, ca. 1620–after 1660), after Titian (Venetian, 1488–1576).* Diana and Callisto, *1660, etching and engraving, 38.4 x 44.8 cm. From David Teniers the Younger,* Theatrum Pictorium…*(Antwerp: Iacobum Peeters, 1684), pl. 96. Los Angeles, Getty Research Institute.*

himself and his royal relatives but also presented himself as a rival to the courts of Europe and therefore a worthy member of the house of Hapsburg. It is easy to imagine how the *Theatrum Pictorium* extended the painting's contents and ideological program far beyond the specific courts to which Teniers's paintings were addressed.

As the archduke's collection passed through inheritance to the house of Hapsburg in Vienna, the persistence of the *Galeriewerke* and their ideological messages can be measured by three publications devoted to the imperial collection. Jacob Männl and Christoph Lauch's unfinished volume of prints (ca. 1720), the *Theatrum Artis Pictoriae* (1728–33), and the *Prodromus* (1735) all focus on this collection and therefore feature many of the same pictures that were reproduced in Teniers's gallery paintings and in the *Theatrum Pictorium*. While the first two suites of prints appear as large presentation albums with 32 and 160 individual images, respectively, the *Prodromus* presents the bulk of the imperial collection in a series of marvelously composed fictive walls (fig. 7). Important pictures such as Titian's *Diana and Callisto* are here reproduced in small format and count as only one of many gems represented on this single page. With over twenty-five similar sheets that display many

FIG. 6. *David Teniers the Younger (Flemish, 1610–90).* Archduke Leopold Wilhelm in His Gallery in Brussels, *ca. 1651, oil on canvas, 104.8 x 130.4 cm. Madrid, Museo Nacional del Prado. Photo: Scala/Art Resource, NY.*

FIG. 7. *Frans van Stampart (Flemish, 1675–1750) and Anton Joseph von Prenner (Austrian, 1683–1761). Paintings from the imperial collection in Vienna, 1735, etching, 33.8 x 25.5 cm. From Frans van Stampart and Anton Joseph von Prenner,* Prodromus *(Vienna: Joannis Petri Van Ghelen, 1735), pl. 21. Los Angeles, Getty Research Institute.*

hundreds of paintings from all schools in the imperial galleries, the *Prodromus* is a decidedly eclectic baroque fantasy that nonetheless reflects the profile of a collection filled with pictures by Albrecht Dürer, Peter Paul Rubens, Frans Hals, Lucas Cranach the Elder, Hans Holbein the Younger, Raphael, Michelangelo, Rembrandt, Annibale Carracci, Caravaggio, and Guido Reni, to name just a few. In this case, the distinction of selectivity has been eschewed in favor of abundance, which presents itself as one of many virtues associated with the princely collection and its related *Galeriewerk*.

FINANCIAL RESPONSIBILITY

By granting the right to publish his or her collection, a patron was not necessarily responsible for financing a publication that would, in any event, broadcast his or her cultural virtues. With the *privilège* as leverage, however, the patron would naturally procure copies of the presentation album and deliver them to a variety of diplomatic recipients, as the archduke Leopold Wilhelm must have done with the Getty Research Institute's copy of the 1660 *Theatrum Pictorium*, whose binding is stamped with his gold-embossed coat of arms. Some patrons were undeniably generous to the publishers, as was the case with the elector of Saxony when he agreed to finance the preliminary production of Heinecken's two-volume *Galerie royale de Dresde* in exchange for one hundred copies of the albums. This arrangement collapsed in part because Heincken was a connoisseur whose ambition to produce one hundred large-scale prints of the highest quality exceeded his experience and resources. The project survived only because of the elector's continued beneficence.

 The extraordinary cost of producing the 1660 *Theatrum Pictorium* was openly lamented by Teniers, who sold copies under his imprimatur through publishers and print dealers in Antwerp and Brussels. In addition to the expense of copperplates, ink, and paper, the process of drawing or painting a preliminary copy of the original composition and then transferring it onto the plate was in itself complex, time consuming, and costly. For his volume, however, Teniers himself was able to produce most of the small, painted copies, later coined *pasticii*, which were used by printmakers to transpose the original composition as well as its tonal values onto the copperplate, most probably through another, intermediary drawing or tracing (figs. 8–10). Such a division of labor was, in fact, the norm for the vast majority of *Galeriewerke*, including those made by the London print publisher John Boydell (1719–1804), who in his *Catalogue of Prints, Published by John Boydell, Engraver in Cheapside* (1773) tried to impress potential collectors by conveniently quoting the production cost of the 164 prints for the first volumes of his *Collection of Prints Engraved after the Most Capital Paintings in England*: "These Two Volumes [produced during the 1760s] have been Ten Years in completing, and cost the Proprietor upwards of Thirteen Thousand Pounds" (p. 13). In the eighteenth century, this sum would have amounted to a substantial fortune. While Boydell was a professional print publisher who easily secured bank loans, other financing, and subscriptions to support his small army of draftsmen and printmakers, many publishers of *Galeriewerke*, most of whom were not professionals in this field, fell victim to unexpected financial strains and economic downturns. Among the casualties in the later eighteenth century were the would-be Düsseldorf *Galeriewerk* publishers, Krahe and Green.

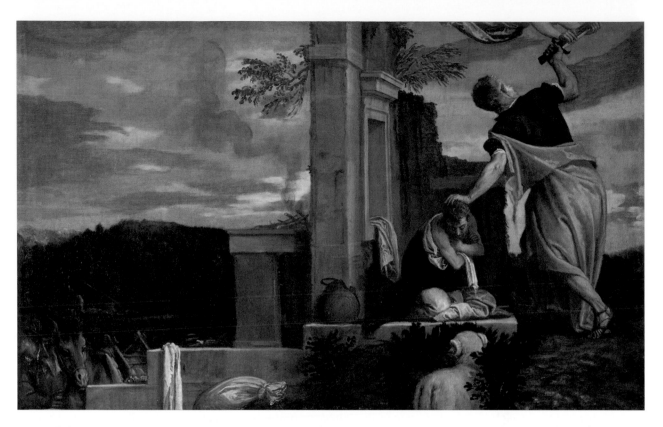

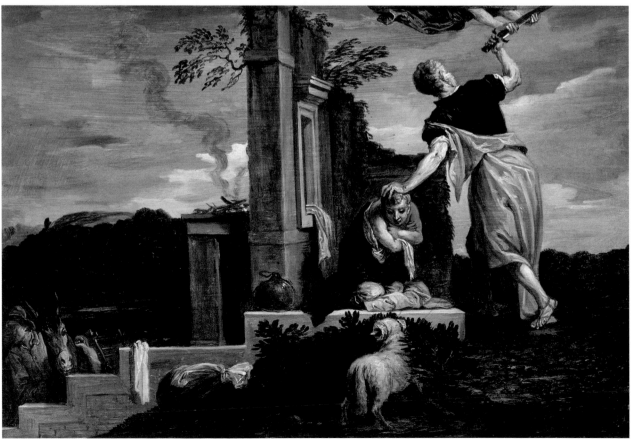

FIG. 8. *Paolo Veronese (Italian, 1528–88)*. Sacrifice of Isaac, *ca. 1580/88, oil on canvas, 103 x 167 cm. Vienna, Kunsthistorisches Museum Wien, Gemäldegalerie. Photo: Erich Lessing, Art Resource, NY.*

FIG. 9. *David Teniers the Younger (Flemish, 1610–90), after Paolo Veronese (Italian, 1528–88).* Abraham's Sacrifice of Isaac, *1654/56, oil on panel, 20.9 x 30.7 cm. Chicago, Art Institute of Chicago. Gift of Mrs. Charles L. Hutchinson, 1936.123. Photography © The Art Institute of Chicago.*

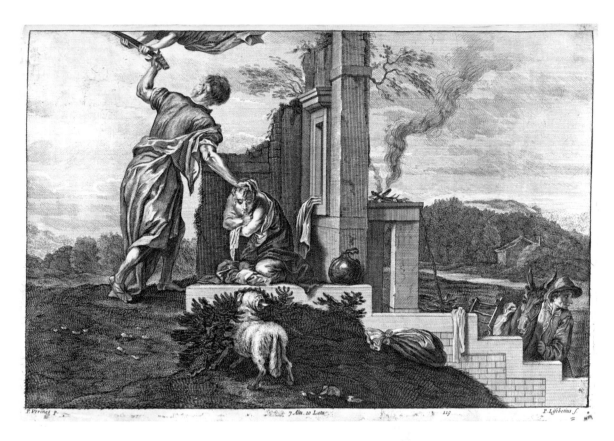

FIG. 10. *Pieter van Lisebetten (1630–78), after Paolo Veronese (Italian, 1528–88). Abraham and Isaac, 1660, etching and engraving, 22.4 x 32 cm. From David Teniers the Younger,* Theatrum Pictorium*…(Brussels: Sumptibus auctoris [David Teniers]; Antwerp: Henricum Aertssens, 1660), pl. 119. Los Angeles, Getty Research Institute.*

FROM PAINTING TO PRINT AND QUALITY CONTROL

For some publishers, a certain amount of financial stress was due to the demands of following the best possible standards of reproduction. Teniers, the publisher of the *Theatrum Pictorium*, avoided certain preliminary costs by making his own *pasticii*. In a few instances, however, printmakers chose to go directly to the original paintings because some of Teniers's copies proved to be inaccurate or even intentionally altered. Turning to the middle of the eighteenth century, Heinecken's approach for the *Galerie royale de Dresde* was somewhat more typical but also excessively ambitious due to his uncompromising expectations. He commissioned the French sculptor and draftsman Charles-François Hutin (1715–76) to oversee the intermediary drawings, which were not only given to printmakers in Dresden, where the collection was displayed, but also expedited to etchers and engravers in Augsburg, Copenhagen, Amsterdam, Rome, and Paris. This unusual distribution of the drawings can be explained by Heinecken's lament that good printmakers were hard to come by. The same seems to have held true for printing presses; although Heinecken's text was published in Dresden, according to him all of the images for volume 2 and most for volume 1 were expertly printed in Paris. Ultimately, one hundred preparatory drawings and corresponding prints were produced by more than ten draftsmen and close to fifty printmakers, which is how the two-volume publication maintained its standard, though it took less than ten years to complete.

The majority of the artists who worked on the *Galerie royale de Dresde* resided in Paris, which

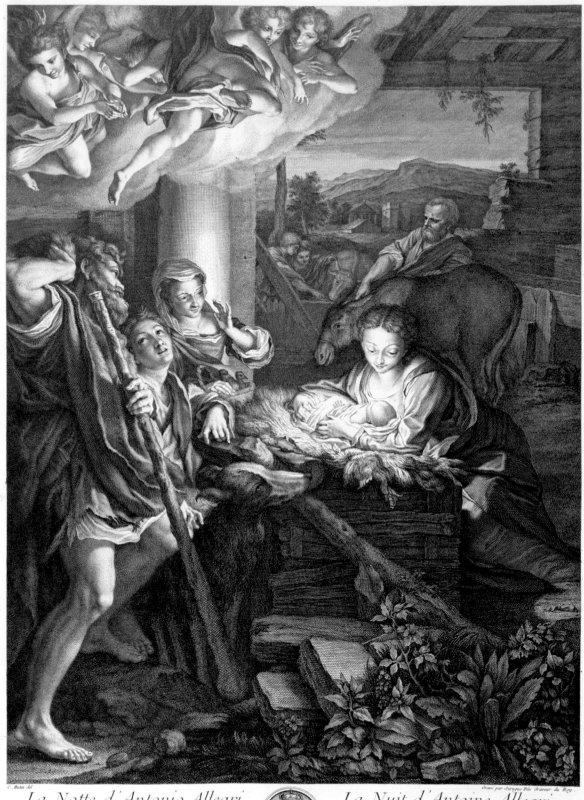

La Notte d'Antonio Allegri
detto il Corregio
Quadro della Galleria Reale di Dresda
Alto piedi 9 e 1 pollice Largo pi 6 poll 8

La Nuit d'Antoine Allegri
dit le Correge
Tableau de la Gallerie Royale de Dresde
Haut de 9 pieds 1 pouce de Large 6 pieds 8 pouc

N.º 1.

C. Hutin del.
Gravé par Surugue Fils Graveur du Roy.

FIG. 11. *Pierre-Louis de Surugue (French, 1716–72), after Correggio (Italian, ca. 1489–1534). La nuit (Adoration of the shepherds), ca. 1753–57,*
etching, 60.2 x 43 cm. From Karl Heinrich von Heinecken, Recueil d'estampes d'apres les plus celebres tableaux de la Galerie royale de Dresde…
64 *(Dresden: Chrêtien Hagenmüller, 1757), vol. 2, pl. 1. Los Angeles, Getty Research Institute.*

continued to maintain its reputation as a great printmaking capital with a critical mass of reproductive engravers who were members of the Académie royale de peinture et de sculpture. Not surprisingly, French engravers were asked to reproduce some of the most important pictures hanging in Dresden (fig. 11). During the production of the plates, proof impressions of the prints were couriered back to that city, where they were "corrected" with the paintings at hand before being returned to the printmaker, who would refine the image on the copperplate. That some examples were corrected more than once in this manner points to the level of control exerted over the project by Hutin and Heinecken, both of whom believed that a successful reproductive print, which had to be large to be effective, faithfully translated an original painting's composition, style, and spirit.

THE REPRODUCTIVE PRINT AS SPOKESMAN AND AS ABSENT WORK OF ART

In the *avertissement* to the first volume of the *Galerie royale de Dresde*, Heinecken takes great pride in the scale of his reproductive prints, among the largest made for any previous *Galeriewerk*. Referring to the difficulties he encountered in locating skilled printmakers, he admits that the final "pieces ne sont pas toutes d'une égale force, les planches aïant été gravées par des maitres deferens" (pieces are not all of equal strength, the plates having been engraved by different masters). Nonetheless, he underscores the significance of his efforts to unite under a single title the "plus habiles graveurs de l'Europe" (most skilled engravers in Europe), suggesting that such differences in quality were useful because they allowed an amateur to train his eye in the art of engraving. This remarkable sentiment is quite distant from the spirit of the earlier *Theatrum Pictorium*, where the function of the relatively modest-sized pictures might have been explained by the contemporary statement in Samuel van Hoogstraten's *Inleyding tot de hooge schoole der schilderkonst* (1678) that "prints are like messengers and spokesmen, that inform us of the contents of works of art that are beyond our reach."[4] While such utilitarianism no doubt concerned Heinecken, he believed that the best reproductive prints were also works of art in their own right. In one example, he impresses this belief upon the reader with his enthusiasm for Jacques Aliamet's (1726–88) rather extraordinary rendition of a now-lost landscape by Nicolaes Berchem the Elder (1620–83) (fig. 12). In addition to celebrating the original, Heinecken's praise is directed toward Aliamet's alluring virtuosity with an etching needle that never betrays the need for formulaic conventions.

The self-consciousness behind the prints in the *Galerie royale de Dresde*, the careful selection of printmakers, and Heinecken's comments on each image aligned the author and the prints with French artists and critics who vigorously defended the dual status of the so-called *gravure d'interprétation* as both a copy of an original and an independent work of art. The two roles assigned to such prints were not so difficult to defend in an era that encouraged all artists to copy, imitate, and emulate. How such seemingly contradictory roles were justified in theory is beyond the scope of this paper, but Heinecken was inspired by publications such as the *Recueil Crozat* (1729–42), a two-volume *Galeriewerk* with illustrations that the editors hoped would function as reproductions and as prints to be admired on their own terms. Heinecken also followed in the footsteps of critics ranging from Florent Le Comte (fl. 1700) to Charles-Nicolas Cochin (1715–90) and Denis Diderot (1713–84), all of whom believed that skilled *graveurs*

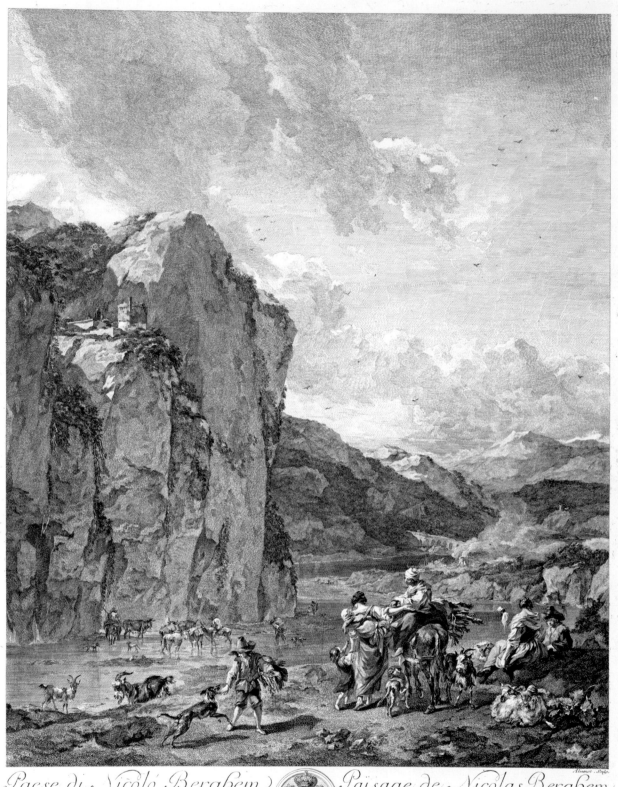

Paese di Nicolò Berghem *Païsage de Nicolas Berghem*

dalla Galleria Reale di Dresda *de la Galerie Roiale de Dresde.*

Alto pi. 5. once . largo pi. 3. once. 1 *Haut 5 pi. 7 pouc. large 3 pi. 1 pouc.*

No: 50

FIG. 12. *Jacques Aliamet (French, 1726–88), after Nicolaes Berchem the Elder (Dutch, 1620–83). Païsage de Nicolas Berghem (Landscape), ca. 1753–57, etching, 58 x 42.9 cm. From Karl Heinrich von Heinecken,* Recueil d'estampes d'apres les plus celebres tableaux de la Galerie royale de Dresde... *(Dresden: Chrêtien Hagenmüller, 1757), vol. 2, pl. 50. Los Angeles, Getty Research Institute.*

d'interprétation were, in effect, "painters without paint," who could make prints that called attention to themselves as works of art.[5] While the rather bold role ascribed to the reproductive print was never universally accepted, defenders claimed that printmakers were like translators whose absolute fluency in two languages meant that the very process of transposing an invention from one medium to another resulted, in the best cases, in a new object that approached the status of an original work of art. At the end of the period, the critic T.-B. Emeric-David, praising the facility of engravers whose tools avoided formulaic linear conventions, claimed that "ils ne gravent pas, ils peignent: c'est-là le triomphe de l'art" (they do not engrave, they paint: this is the triumph of art) (*Discours historique sur la gravure en taille-douce et sur la gravure en bois* [1808], p. 59). If such a triumph was to be attained by a *Galeriewerk* publisher such as Heinecken, for example, he had to contend with extraordinary production costs in order to assure that the reproductive prints would be judged favorably as faithful copies and beautiful prints.

PART II. THE FIRST FAILED DÜSSELDORF *GALERIEWERK*

It may have been Heinecken's *Galerie royale de Dresde*, made for the elector of Saxony, that inspired the elector Palatine, Carl Theodor, to promote his collection through print. The initial attempt—which proved to be a failure—was undertaken by Lambert Krahe, painter and director of the Düsseldorf gallery, whose brief it had been to reinstall the elector's pictures in the 1760s.[6] In 1773, Krahe established the elector's academy of painting, sculpture, and architecture (formerly Krahe's drawing academy) from which he commissioned artists to prepare his *Galeriewerk*.

The Düsseldorf gallery that came under Krahe's directorship in 1756 had been established around 1710 to house the collection of Carl Theodor's ancestor, Johann Wilhelm II von der Pfalz (1658–1716) and the electress Anna Maria Luisa de' Medici (1667–1743), the daughter of Cosimo III of Tuscany, who during this decade would complete the aforementioned *Grand Duke's Cabinet*. In 1756, Krahe became gallery director and after the end of the Seven Years' War (1756–63) reorganized the collection, eschewing the standard installation practice of covering walls from floor to ceiling in favor of a more systematic approach that emphasized the relative importance of each painting organized by school. The treasures included forty-six paintings attributed to Rubens, at least twenty-five to Adriaen van der Werff (whose finely finished cabinet pictures commanded headline-making prices), and nine to Rembrandt, as well as works attributed to Raphael, Jacob Jordaens, and numerous other noteworthy figures. With these treasures at hand, Krahe must have envisioned himself in the position of Heinecken or Teniers, both of whom had secured *privilèges* to reproduce the masterpieces under their care.

In 1768, Krahe was granted a *privilège* to copy the Düsseldorf pictures with the stipulation that any preparatory drawings would be handed over to the elector Carl Theodor. Judging by the range and quality of the preparatory drawings, Krahe was allowed to copy all the paintings for the purpose of producing a presentation album of the highest quality at his own expense for his potential profit. To that end, he commissioned talented draftsmen who taught at the academy to make those drawings in anticipation of having the images engraved such that the subject matter and the individual style of each original

FIG. 13. *Johann Elias Haid (German, 1737–1809), after Adriaen van der Werff (Dutch, 1659–1722).* Frontispiece, Allegory of Johann Wilhelm II von der Pfalz, Elector of Palatine, and His Wife Venerated by the Arts, *ca. 1771, mezzotint, 72.9 x 48.4 cm. Braunschweig, Germany, Herzog Anton Ulrich-Museums. Braunschweig, Kunstmuseum des Landes Niedersachsen. Fotonachweis: Museumsfotograf.*

artist could be analyzed by collectors of the prints. How these hundreds of drawings, most of which are now in the Getty Research Institute's special collections, were taken from Krahe at the elector's behest and used in the mid-1770s for the production of a very different kind of book, *La galerie électorale de Düsseldorff* (1778), is discussed by Gaehtgens in this volume.

Krahe's initial optimism was palpable in the published notice, which called for subscribers to acquire the as-yet-unpublished prints after one of the "plus riches Collections de l'Europe" (richest collections in Europe).[7] Insisting that these reproductive images would be of the highest quality, the notice mentioned that the images were to be printed on luxurious "grand Papier Roiale." (We can imagine that Krahe had Heinecken's albums in mind.) Evidently, a would-be subscriber could gauge Krahe's intentions by the initial four large mezzotints by Johann Elias Haid (1737–1809). In addition to reproductions of Van der Werff's *Visitation*, *Annunciation*, and *Nativity* (Schleißheim, Staatsgalerie),

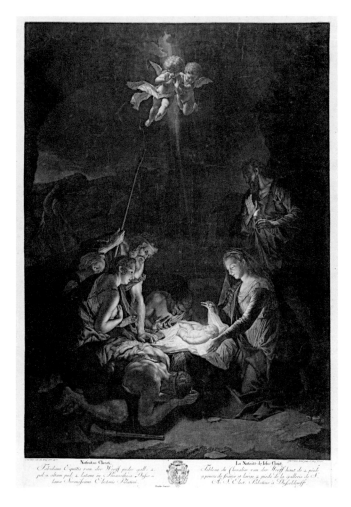

FIG. 14. *Johann Elias Haid (German, 1737–1809), after Adriaen van der Werff (Dutch, 1659–1722).* Nativitas Christi *(Nativity), ca. 1771, mezzotint, 73.3 x 47.9 cm. Braunschweig, Germany, Herzog Anton Ulrich-Museums. Braunschweig, Kunstmuseum des Landes Niedersachsen. Fotonachweis: Museumsfotograf.*

Haid reproduced the famous allegory honoring Johann Wilhelm II and his Medici wife as patrons of the arts (figs. 13, 14). At the bottom of the inscription field, the elector Palatine's coat of arms sits above "Krahe direxit" and is flanked by dedications in Latin and French that addressed a European market, as well as copyrights that covered the Palatine and the Holy Roman Empire. The label "Frontispiece" clearly identifies the function of the print, which also reflected the purpose of the original painting as an introduction to the cycle of Rosicrucian mysteries executed by Van der Werff for Johann Wilhelm II. In the context of Krahe's intended collection album, the picture naturally served as a historical reminder of the gallery's founder and as a dynastic marker for the patron, Carl Theodor.

The decision to begin the collection album with a suite after Van der Werff was certainly calculated to attract the attention of potential subscribers, given this artist's reputation among collectors in the eighteenth century. Although acerbic critics such as Jean-Baptiste Descamps (1706–91) disparaged

Van der Werff's highly polished paintings with remarks like "Sa couleur...est froide & sent un peu l'ivoire" (Its color . . . is cool and seems a bit like ivory), his paintings were loved by the educated public, as were the stories of how they had fetched astonishingly high prices during the painter's lifetime (*La vie des peintres flamands, allemands et hollandois* [1760], vol. 3, p. 393). Money and fame were embedded in this painter's story. For an extraordinary sum that made him one of the highest-paid artists of the early eighteenth century, a kind of superstar painter *avant le lettre*, Van der Werff had agreed to work exclusively on behalf of Johann Wilhelm II for six months of every year. Ultimately, the Düsseldorf gallery boasted the largest number of works by him, with one of the galleries carrying his name.

Despite his best efforts, Haid's reproductions of the Van der Werff images proved to be a disappointment to Krahe, whose standards and good taste might have been challenged by details such as the figure of the infant Christ in the *Nativity* (whose body resembles the intestines of a medium-size mammal rather than a plump and healthy infant). Evidently, Haid was not entirely comfortable with the mezzotint instruments, namely the rocker and scraper, which required the artist to work from a dark surface to light rather than the standard light surface to dark.[8] In the hands of an average artist, this process resulted in stultifying images. But in the hands of a master, the range of tones approached that of a painting and as such appealed to a large audience both in England, the undisputed center of the mezzotint, and on the Continent, where mezzotints were exported in great numbers. The mezzotint also had an advantage over the more typical line engraving and etching favored by Heinecken in his *Galerie royale de Dresde*, especially the controlled, hard-ground etching and mixed etching-and-engraving techniques favored by French academic printmakers such as Pierre-Louis de Surugue (1716–72) (see fig. 11). Because it was less time consuming to make a mezzotint, it was significantly less expensive for a publisher to cover the costs of production.

Krahe may have relied on Haid for at least two reasons. Given his chronic financial difficulties, Krahe must have been attracted to the relative efficiency of the mezzotint technique, which Haid may have practiced in London or learned from his uncle Johann Gottfried Haid (1710–76).[9] According to some sources, both men were in the English capital in the 1760s working with John Boydell, whose successful print-publishing enterprise helped make the reproductive mezzotint a staple of the English and Continental markets. No doubt the popularity of the mezzotint contributed to Krahe's decision to produce a *Galeriewerk* of mezzotints, and relying on native talent must have seemed, at least initially, to be a logical decision.

If Johann Elias Haid's credentials as a onetime apprentice to Boydell got Krahe's attention, so too did the Haid family publishing enterprise in Augsburg, where the four prints after Van der Werff appear to have been published by Johann Elias, who had taken over his father's business in the late 1760s. In fact, both parties could have benefited from this arrangement. For Haid, the proposition to devote his press to a *Galeriewerk* of a famous collection must have been an attractive opportunity. (Haid would later reproduce a few of the elector's pictures.) For Krahe, the advantages were obvious, for he could rely on an experienced printmaker and publisher, both of which Düsseldorf evidently lacked. In any event, by 1771 he realized that Haid was incapable of fulfilling his demands, as all that he had to show for his efforts at that moment were Haid's four prints, which evidently neither satisfied Krahe nor attracted the necessary subscriptions to pay for printmakers, copperplates, ink, and paper.

PORTRAIT DE REMBRANDT.

Suivi de huit autres planches, le toul d'après les tableaux originaux du même : formant une col= =lection complette de ce qui se trouve de Rembrandt Dans la Gallerie Electorale a Düsseldorff.

Dedié aux amateurs de ses ouvrages.

L. Krahe direxit.

FIG. 15. *Carl Ernst Christoph Hess (German, 1755–1828), after Rembrandt van Rijn (Dutch, 1606–69).* Portrait de Rembrandt, *ca. 1783, etching, 33.5 x 22.7 cm. London, British Museum (1915,0106.39). Photo © The Trustees of the British Museum.*

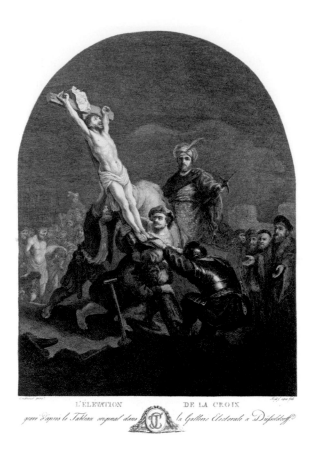

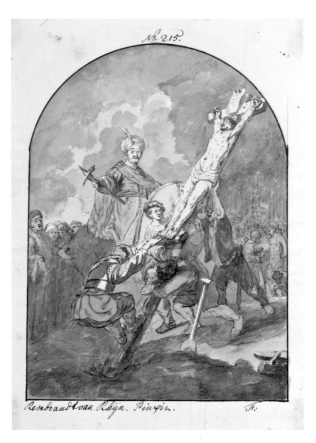

FIG. 16. *Carl Ernst Christoph Hess (German, 1755–1828), after Rembrandt van Rijn (Dutch, 1606–69).* L'élévation de la croix (Raising of the Cross), *1783, etching, 32.1 x 22.5 cm. London, British Museum (1861,1109.291). Photo © The Trustees of the British Museum.*

FIG. 17. *Jean-Victor Frédou de la Bretonnière (French, b. 1735), after Rembrandt van Rijn (Dutch, 1606–69).* Raising of the Cross, *ca. 1768–ca. 1775, wash, graphite, pen, and ink. From a leather-bound volume of drawings after paintings in the Düsseldorf gallery, p. 45v. Los Angeles, Getty Research Institute.*

In the early 1770s, Krahe attempted to set up an arrangement similar to the one he had established with Haid, but this time in London with Boydell, whose reproductive prints proved popular throughout Europe. In the 1760s and 1770s, Boydell had embarked upon two impressive sets of prints, available by subscription, one being the *Collection of Prints Engraved after the Most Capital Paintings in England* and the other of the Walpole collection at Houghton. Although most of the masterpieces at Houghton were sold to Catherine II of Russia at the end of the 1770s, Boydell and his small army of excellent printmakers would complete work on the prints in 1788. Given Boydell's commitments, he likely could not have undertaken another expensive venture, which must have appeared riskier than usual given the distance between Düsseldorf and London. In the end, Krahe failed to establish a partnership of any sort. Unable to recoup the funds that underwrote the production of the preparatory drawings (discussed by Gaehtgens in this volume), Krahe was forced by insurmountable financial difficulties to sell his own very splendid collection of old master drawings to the academy and then finally, in 1780, according to Heindrun Rosenberg, to declare an end to his quest to produce a *Galeriewerk*.[10]

L'APARITION DE IESUS — CHRIST A S. MADELAINE.
D'apres un Tableau Original de la — Gallerie Electorale de Dusseldorff.

FIG. 18. *Heinrich Schmitz (German, 1758–87), after Federico Barocci
(Italian, 1528–1612). L'aparition de Iesus Christ a S. Madelaine
(Apparition of Jesus Christ to Saint Mary Magdalene), ca. 1780–87,
etching and engraving, 28.7 x 35.5 cm. London, British Museum
(1917,1208.741). Photo © The Trustees of the British Museum.*

Krahe and Printmakers

One of Krahe's main obstacles was the lack of good, local engravers, a problem faced by *Galeriewerk* publishers before him. He attempted to address the shortage by using his position as the director of the art academy to encourage the development of young printmakers. Two of the most promising artists turned out to be Heinrich Schmitz (1758–87) and Carl Ernst Christoph Hess (1755–1828), both of whom would become members of the academy and marry into Krahe's family.

Hess, who had been laboring on minor decorative prints, was called to Düsseldorf by Krahe in 1777 to work on engravings after paintings in the gallery. On the basis of his etchings after Rembrandt's paintings, he was admitted to the academy in 1780; in 1782, he was appointed professor of that institution as well as engraver to the court. What Hess made under Krahe's direction was not the *Galeriewerk* imagined by Krahe. Instead, it was a suite of small-scale prints after Rembrandt, which appeared in 1783 with a title page adorned by the Dutch master's self-portrait (fig. 15), after a painting now considered to be a copy of the original in Vienna. The "livre" is dedicated "aux amateurs de ses ouvrages" (to the amateurs of his works), and its title page, with the beautifully etched initials of Carl Theodor, explains that the images reproduce all the Rembrandts in the elector's collection. Along with two portraits now attributed to Ferdinand Bol, six other prints reproduce small paintings now in Munich that depict scenes from the life of Christ, including the Raising of the Cross (fig. 16). Of modest size, each image is inscribed "Hess f[ecit] aqua forti," which in and of itself is not unusual but perhaps noteworthy given that Hess's tenebrous etching style appears to evoke the tonality of Rembrandt's etchings, which continued to be valued by collectors in the eighteenth century. Of course, Hess's etchings have little to do with the Dutch master's graphic masterpieces, but during this period the densely packed combination of tremulous and free-flowing lines was associated with Rembrandt, as in the case of Georg Friederich Schmidt's well-known *Self-Portrait with a Spider's Web* (1758), a print famously emulating Rembrandt's self-portrait of 1648.

Hess's pictures are not based on the graphite-and-wash copies of the elector's Rembrandts made by Krahe's draftsmen sometime between 1768 and 1775 (fig. 17). Those drawings had been sent

to Brussels for the production of the two-volume *La galerie électorale de Dusseldorff*, published the year after Hess arrived in Düsseldorf. The significant differences between the etched and drawn reproductions are explained in part by the different artists who copied them and by the state of the paintings themselves, which were in remarkably poor condition according to inscriptions on the drawings. Since Hess's brief was undoubtedly to present the pictures in the best possible light, he may have taken the liberty of "restoring" them as he reproduced them in etching.

Although it might seem unlikely given that the Rembrandt suite was published as a discrete book, it is possible that the idea for the suite of small Rembrandt pictures began as a plan for a new *Galeriewerk*. In fact, at least four other etchings after Italian masters, with dimensions similar to those of Hess's Rembrandts, were made by or produced under the direction of Krahe's other favorite engraver, Heinrich Schmitz (fig. 18). With Krahe's help, Schmitz spent four years in Paris apprenticing with Johann Georg Wille (1715–1808) and became one of the leading printmakers in Düsseldorf along with Hess. It may very well be that these two artists, closely allied with Krahe, were caught up in the dream of producing a presentation album, now on a much-reduced scale, that mirrored more modest examples such as the *Recueil d'estampes gravées d'après les tableaux du cabinet de Monseigneur le duc de Choiseul* (1771), illustrated with etchings less than 13 inches high. The question of a relationship between the sets of prints by Hess and Schmitz needs further investigation. What is certain is that, with Schmitz's untimely death in 1787, there seems to have been no further possibility of publishing a *Galeriewerk* in Düsseldorf itself.

The Second Failed Düsseldorf *Galeriewerk:*
Valentine Green and His *Descriptive Catalogue of Pictures from the Dusseldorf Gallery, Exhibited at the Great Room, Spring Gardens*

In 1789, twenty years after Krahe secured his *privilège*, the elector Carl Theodor granted to the English printmaker Valentine Green and his son Rupert (1768–1804), a "patent of Exclusive Privilege for fourteen years" to engrave and publish "all, or any of the Pictures in the Gallery of Dusseldorf, to their own use and benefit, at their

FIG. 19. *Valentine Green (English, 1739–1813), after Peter Paul Rubens (Flemish, 1577– 1640).* Samson Betrayed by Delilah, *1793, mezzotint, 56.8 x 61.2 cm. Los Angeles, Getty Research Institute.*

BY DELILAH. SAMSON TRAHI PAR DALILA.

Engraved by V. Green, Mezzotinto Engraver to his Majesty & to the Elector Palatin.

....e, Elector Palatine, Reigning Duke of Bavaria &c.&c. &c. This Plate Engraved by his Gracious Permission

....Dufseldorf, is Dedicated by his Most Devoted and Obedient Humble Servants

 Valentine Green.

 Rupert Green.

....Pigages Catalogue of the Dufseldorf Gallery, this Subject is N.º 269 Published Nov.ʳ 1 1793 by V & R. Green N.º 15. Berners Street, London.

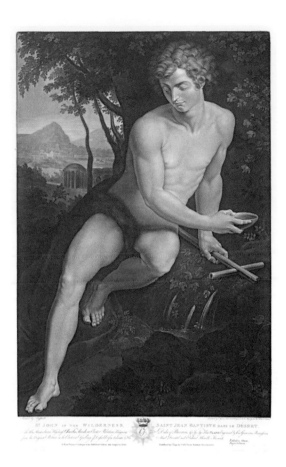

FIG. 20. *Valentine Green (English, 1739–1813), after Raphael (Italian, 1483–1520), now attributed to Daniele da Volterra (Italian, ca. 1509–66).* Saint John in the Wilderness, *1792, mezzotint, 66 x 40.5 cm. Los Angeles, Getty Research Institute.*

FIG. 21. *Valentine Green (English, 1739–1813), after Adriaen van der Werff (Dutch, 1659–1722).* The Visitation, *1794, mezzotint, 66 x 43 cm. Los Angeles, Getty Research Institute.*

own risk and expence." While such an arrangement between distantly located collector and publisher was unusual, it must have been the flourishing international print trade in London that gave the elector some hope for success. The details of the project that ambitiously linked the elector's collection to the commercial enterprise in London are described in *A Descriptive Catalogue of Pictures, from the Dusseldorf Gallery, Exhibited at the Great Room, Spring Gardens* . . . (1793). The exhibition contained two groups of objects. The first consisted of seventy-two small, painted copies of pictures in Düsseldorf that were to be engraved by Green and his printmakers, while the second group, available for immediate purchase, comprised fourteen reproductive prints, one of which was also available in a handcolored version and two of which were unfinished proofs (figs. 19–22). The goal of the exhibition was to show the impressive progress of the Greens' Düsseldorf *Galeriewerk* and thereby entice collectors into subscribing to the entire proposed suite of one hundred prints, which in the end was to be bound by the collector in the order specified by the publishers. Unfortunately, of the hundred large prints promised by the Greens, only twenty-one appear to have been completed before Valentine and Rupert were declared bankrupt in 1798, the end of the decade that witnessed the decline of the *Galeriewerk* tradition throughout Europe.

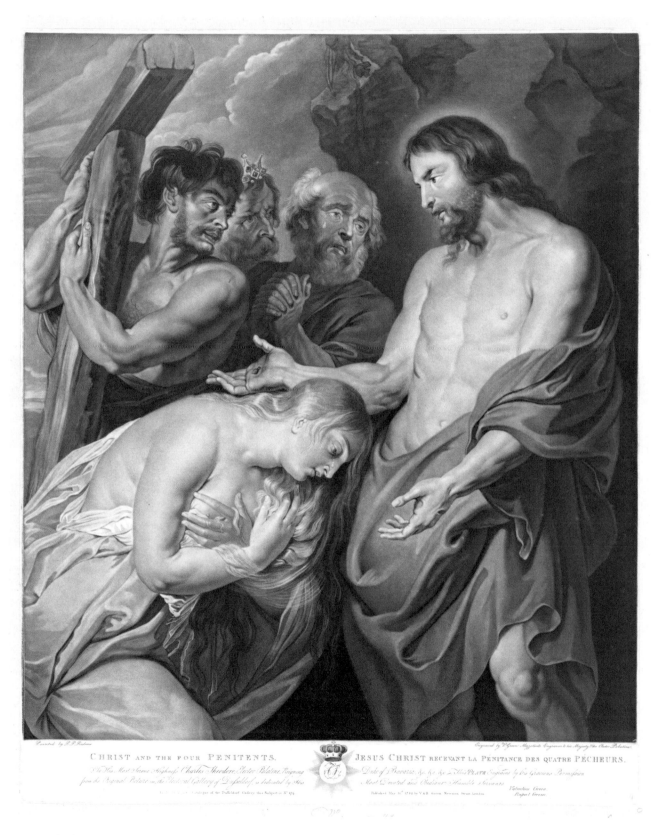

FIG. 22. *Valentine Green (English, 1739–1813), after Peter Paul Rubens (Flemish, 1577–1640).* Christ and the Four Penitents, *1792, mezzotint, 63.8 x 50.7 cm. Los Angeles, Getty Research Institute.*

Valentine Green, Printmaker and Print Publisher

In a forty-year period beginning in 1769, Green produced over 350 prints and published many more from the hands of other printmakers.[11] He was considered an outstanding mezzotint artist, admired for carefully preparing his plates with a finely toothed rocking tool, producing the kind of "smoky" effect (to use a term quoted in Joseph Farington's diaries) that was much admired in his engraved portraits after Joshua Reynolds and in historical scenes after old and new masters, many of which commanded prices in the upper reaches of the print market. In the 1770s, he made images for the publisher Boydell, who proved to be a model for Green. After the middle of the century, Boydell had transformed himself from a mezzotint engraver into a publisher who concentrated almost exclusively on the sale of reproductive prints in the domestic and European markets. In the 1760s and 1770s, he took advantage of the public's interest in aristocratic collections and embarked upon the *Collection of Prints Engraved after the Most Capital Paintings in England* (1769–92) and the so-called *Houghton Gallery* (1773–78), both of which were critically acclaimed and financially successful models for Green.

In the 1770s, Green worked primarily for Boydell, producing large-scale mezzotints of old master pictures by the likes of Rubens, Teniers, and Annibale Carracci, as well as contemporary works such as Benjamin West's *Regulus Returning to Carthage* and *Hannibal Swearing Enmity to the Romans*, published in 1771 and 1773, respectively. On the strength of these two historical compositions, Green was appointed mezzotint engraver to King George III. In 1774, he entered the ranks of the Royal Academy of Arts as one of its six associate engravers. In the following year, Green was traveling through parts of northern Europe when he came to the attention of the court in Mannheim (where Carl Theodor resided) and was appointed engraver to the elector and professor at the academy in Düsseldorf. In 1777, Green published a portrait of the elector after Pompeo Batoni's original (see p. 4, fig. 5) and received an expensive gold medal as a reward. No doubt Green's appointments and recognition served the needs of Carl Theodor and Krahe. They also buttressed Green's rising reputation and fueled his ability to solidify business contacts on the Continent, which was one of the purposes of his trip. In effect, Green was doing what Boydell and others had done by establishing relations with a network of publishers, dealers, and middlemen who were key fixtures in the thriving international print trade, which had become essential to the success of the English print publishers.[12]

In Düsseldorf, Green met Johann Gottfried Huck, a print dealer who was to become a leading importer of British prints for the German-speaking market. No doubt, Huck must have proven a good contact by the time Green issued his first catalogue as a print publisher in 1780. In 1782, Huck's son Gerhard (1740–1811) was sent to London to apprentice with Green. Residing there for a few years, Gerhard emerged as an invaluable printmaker, draftsman, and painter who made numerous preparatory drawings and paintings for prints published by the Greens. When Valentine and Rupert received their exclusive patent to publish the Düsseldorf collection, the task of copying the paintings fell to Gerhard, who was also entrusted to oversee "several artists of eminence" to paint "cabinet size" copies of the elector's pictures. The copies from which the prints were to be made were sent to London as they were completed.

Green's exhibition of these small, painted copies in 1793 was not an entirely new phenomenon. In London, original paintings had been routinely exhibited to induce subscriptions since at least the

1760s. Print publishers such as Boydell also exhibited their work on a regular basis in a number of different venues.[13] In 1770, he opened an exhibition related to his ongoing multivolume *Collection of Prints Engraved after the Most Capital Paintings*. A fourteen-page catalogue listed 109 of the preparatory drawings that had been used to make the prints for this publication. Of course, these were exhibited to convince collectors to buy prints that had already been produced and to subscribe to the rest of the project. But the drawings themselves were also offered for sale, their proceeds meant to finance subsequent volumes of Boydell's successful publication, which would terminate with a ninth volume in 1792.

Green himself was not a stranger to exhibitions. However, his 1793 installation in Spring Gardens was less typical than most such events. His strategy of exhibiting "old master" paintings, albeit in the form of highly finished copies that were not for sale, played upon the frequent and popular temporary exhibitions of paintings, especially in 1793, when well-received masterpieces from the former collection of the duc d'Orléans were on constant display in many different venues throughout London (see figs. 2, 3). Most likely inspired by Boydell's success, Green also seems to have counted on the excitement of the 1793 exhibition season to generate subscriptions that would propel his own *Galeriewerk* toward completion.

The 1793 Exhibition of Düsseldorf Copies in London

As with most exhibitions, the Greens exhibited their painted copies and prints in the spring, from early April through the end of June. According to the numerous advertisements that appeared in the *London Times* from 10 April through 21 June 1793, the entrance fee was one shilling, which included the cost of a catalogue. Two catalogues were available to prospective buyers. The short, eight-page *Catalogue of Pictures*, which may have been free, is in effect a list of paintings and prints, while the *Descriptive Catalogue of Pictures* is a fifty-nine-page booklet that includes a historical account, description, and plan of the Düsseldorf gallery. This larger catalogue also includes a version of the smaller catalogue, which seems to have caused some confusion about Green's proposed *Galeriewerk* in the scholarly literature. The terms and conditions of the subscription are outlined in precise detail. Collectors could subscribe immediately to all or any of the prints in the initial set of twenty-five large prints, fourteen of which were on view in Spring Gardens. Presumably, a collector would gauge his interest in the eleven other works, as well as the entire offering, by examining the paintings in the exhibition. In order to maximize interest and profit, subscribers were given a choice of acquiring all or some of the prints, which were to be released in pairs at specified intervals during the following few years.

Printed on luxurious Grand Colombier paper, the Düsseldorf prints matched or exceeded the mezzotints by Haid in size. The prices of Green's sheets were within the range of those offered by his competitors, with *Saint John in the Wilderness* at one pound sterling and the pictures after Van der Werff one pound sterling, eleven shillings, and sixpence each. Proof impressions of the mezzotints were limited to fifty and were offered at double the advertised price for each print, as was a handcolored impression after Guido Reni's *Assumption of the Virgin* (Munich, Alte Pinakothek).

Green's ambitious project had to contend with the potential discomfort felt by any collector about a subscription that reproduced pictures inconveniently located on the Continent. In this respect, Green's *Galeriewerk* is a rather unique case, for no other such publication seems to have been produced

in this manner, with the exception of Jean Baptiste Joseph Wicar's *Tableaux, statues, bas-reliefs et camées de la galerie de Florence . . .* , known as the *Galerie de Florence et du Palais Pitti*, published in Paris between 1789 and 1807. In order to assure clients that the painted copies were faithful reproductions of the originals in Düsseldorf, which could not be measured against the reproductive prints in London, the *Descriptive Catalogue* gives a few details about the operation directed by Gerhard Huck in the elector's gallery:

> The Edifice of the Gallery consists of a ground floor, of which those apartments beneath the first and second rooms of the Picture Gallery, are now appropriated to our use. In these the copies of the Pictures are executed; and a complete Series of the Prints which we have published from the Collection, is arranged in one of those apartments, now known as the *Print Room*. (p. 6)

Pointing to the proximity of the originals to the prints may have inspired a sense of confidence in the reproductions themselves, which were also for sale in Düsseldorf.

The catalogue indicates that the carefully painted copies were similar to "cabinet size" pictures except in the case of Gerrit Dou's *Quack Doctor*, Rubens's *Fall of the Damned*, and the entire group of Van der Werff's paintings. These copies were the exact dimensions of the originals, a fact that did not go unnoticed in the contemporary responses to the exhibition.

> The copy of that celebrated chef d'ouvre [*sic*] of the Charlatan, by Gerard Dow, which forms the center-piece of the Collection from the Dutch School, in Mess. Green's Exhibition of Pictures from the Düsseldorf Gallery, is allowed, by the most competent judges, to be an uncommon exertion of the imitative Arts; and were it not known that the original cannot be removed from the Gallery, it would be no impeachment to the most judicious and critical eye to have pronounced it the work of that celebrated master. (Press cuttings [Getty Provenance Index], 1793, vol. 3, p. 658)

Such acclaim revealed not only the universally positive responses to the exhibition's paintings but also the time taken by Huck and his painters to copy the works with the utmost care. The other paintings that received almost as good a response were by Rubens, Van der Werff, and Godfried Schalcken. It is perhaps not a coincidence that these pictures had the longest entries in Green's catalogue. With the exception of Rubens's *Fall of the Damned*, Dou's *Quack Doctor*, and Van der Werff's *Entombment*, the vast majority of the entries are brief and reveal little about the selection of pictures or the publisher's aesthetic prejudices. In many cases, details about the paintings are translated from the catalogue *La galerie électorale de Dusseldorff*, including opinions about attributions and facts regarding the original work's provenance. However, the aesthetic strategy, promoted in Pigage's book and discussed by Gaehtgens, is largely absent from the entries in the Greens' sales catalogue.

In addition to newspaper comments on individual paintings, at least one critic praised the display of the pictures in Spring Gardens and by extension the quality of the painted works as a whole:

> To the advantageous arrangement of the Pictures from the Düsseldorf Gallery, much of the pleasurable arrangement in viewing the Exhibition . . . evidently arises. The different

schools being separated, we are instantaneously struck with those distinctions of stile in composition, colouring, drawing, and effect which each of them had peculiar to themselves. (Press cuttings [Getty Provenance Index], vol. 3, p. 649)

The "gratification of the frequenters" being noted, this reception of the exhibition points to one of the most fascinating aspects of Green's proposal, that is, his stated intention not to favor any single school but rather to make a liberal selection of artists in order to appeal to the inclinations of a diverse group of amateurs throughout Europe. The commercial aspects of this strategy are obvious, especially given that subscribers were not committed to purchase every print. In his selection of works, however, Green must have been inspired by Krahe's innovative installation of the pictures, which allowed viewers to grasp the individual characteristics of each school and the relative value of each artist. Green's selection of the seventy-two completed copies was more or less equally distributed throughout the Düsseldorf gallery. He chose from room I (Flemish Gallery), eleven pictures; from room II (Dou Gallery), ten pictures; from room III (Italian Gallery), sixteen pictures; from room IV (Van der Werff Gallery), sixteen pictures; from Room V (Rubens Gallery), fourteen pictures; and five additional *tableaux mobiles*, pictures that were hung on the closed interior window shutters of the Düsseldorf gallery. In effect, Green's proposed *Galeriewerk* mirrored the intelligent arrangement of the pictures in Düsseldorf, and to that end each of the completed prints is inscribed with the catalogue number given in Pigage's *La galerie électorale de Dusseldorff*, which corresponded to an entry and to the illustrated elevations that showed the actual positions of the pictures in the galleries.

Green's ambitions were quite clear. Relying on the well-organized Düsseldorf collection, he presented a coherent selection of paintings that in content, size, and format was meant to outdo the likes of Teniers's *Theatrum Pictorium*, Heinecken's *Galerie royale de Dresde*, and Boydell's *Houghton Gallery*, as well as "every other [publication] that is at this period under execution in Europe," the two most prominent being the so-called *Galerie du Palais royal* (also *Galerie du duc d'Orléans*) with 354 images and the *Galerie de Florence et du Palais Pitti* with 200 images. The latter two appeared in 1786 and 1789, respectively, but were not completed until after 1800. The illustrations in both these Paris-based publications outnumbered Green's proposal; however, they were less than half the size of those published by Green. Moreover, the images printed in Paris tended toward a dry utilitarianism that was as foreign to Green's majestically large, artistic reproductions as they were to those published by the likes of Heinecken and Boydell earlier in the century.

Valentine Green and His Printmakers

The inscriptions on the prints point to Green's ambitions. In addition to indicating that he and his son were the publishers (on all but one of the prints), the titles of the works in French and English are directed toward a domestic and European audience. The success of his project required him to secure the services of the best artists, and to that end the *Descriptive Catalogue* lists the printmakers whose names were to appear on the prints. These include William Sharp (1749–1824), James Heath (1757–1834), John Landseer (1763/9–1852), and Francesco Bartolozzi (1727–1815). Like Green, some of these artists had also worked

for Boydell, and as such they constituted an impressive roster of well-known masters in line, stipple, and mezzotint engraving. With the exception of Green, however, not one of these names was inscribed on the plates, a sign that Green's financial difficulties had begun even before his exhibition at Spring Gardens opened to the public. The only other contributing printmakers were two Englishmen of little note, Lawrence Jean Cosse (ca. 1758–1838?) and John Eginton (active 1763–1800), and two Germans affiliated with the Düsseldorf Academy, Ernst Carl Thelott (1760–1834) and Krahe's former collaborator Carl Ernst Christoph Hess, the author of the prints after Rembrandt's paintings in Düsseldorf.

The somewhat confusing arrangement of the lists of prints in the *Descriptive Catalogue* has misled authors such as Alfred Whitman about the actual prints published by Green for his Düsseldorf project. Thus far we have identified twenty-one images in the appendix to this essay. Green himself produced fifteen mezzotints, the greatest number by any of the printmakers. From 1791 to 1796, he reproduced works attributed to Raphael, Van der Werff, Carracci, Giordano, Jordaens, Van

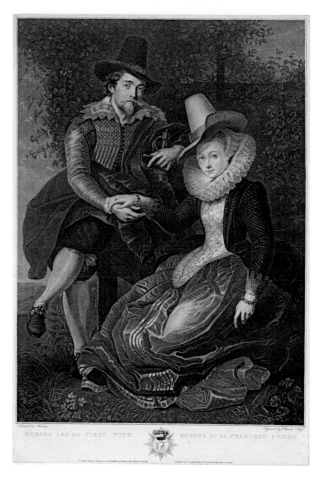

FIG. 23. *Carl Ernst Christoph Hess (German, 1755–1828), after Peter Paul Rubens (Flemish, 1577–1640).* Rubens and His First Wife, *1796, stipple and engraving, 63.6 x 41.7 cm. London, British Museum (1891,0414.1321). Photo © The Trustees of the British Museum.*

Dyck, Schalcken, and Rubens. Given the mixed quality of the details in the examples illustrated here, Green appears to have relied upon his own skill as much as that of workshop assistants, who would have been assigned to work on some of the less important parts of the compositions.

Of particular note are Hess's three stipple engravings, which were considered by nineteenth-century biographers to be among the best of the group (figs. 23, 24). When Hess was asked to join Green, he apparently had no training in the stipple technique but evidently rose to the occasion, perhaps with the help of Bartolozzi, the preeminent stipple engraver of the eighteenth century. Given the quality of the engraved *Quack Doctor*, and the reception of both the painted copy in London and the original in Düsseldorf, it appears Green planned to assign the best pictures to the artists most capable of faithfully rendering their character. For *The Quack Doctor*, Hess not only translated the contours and details of the various characters and objects that populate the composition but also used a sophisticated graphic vocabulary to capture the quality of light and sense of textures and reality that made the painting so rightly famous.

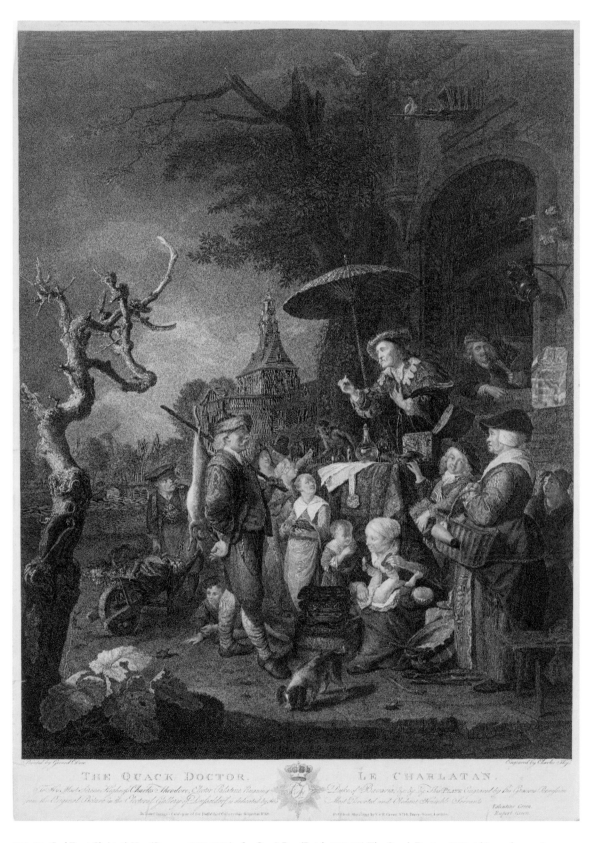

THE QUACK DOCTOR. LE CHARLATAN.

FIG. 24. *Carl Ernst Christoph Hess (German, 1755–1828), after Gerrit Dou (Dutch, 1613–75).* The Quack Doctor, *1797, etching and engraving, 66.7 x 47.4 cm. London, British Museum (1861,1109.58). Photo © The Trustees of the British Museum.*

Bankruptcy and Prints

Between the time of the Spring Gardens exhibition in 1793 and their eventual bankruptcy in 1798, the Greens published a meager number of prints, most of which were for the Düsseldorf project. That Bartolozzi and the other artists named in the *Descriptive Catalogue* never participated in the project is surely a sign that the Greens were unable to attract enough subscriptions to cover the costs of hiring such well-established printmakers. That the early newspaper accounts focused on the painted copies in the 1793 exhibition rather than on the prints might be taken as a sign of disinterest or displeasure.

A shortage of subscriptions was not the only obstacle encountered by the Greens. In the November 1813 issue of *Gentleman's Magazine*, one of Valentine's former collaborators, James Ross, wrote in response to a notice about the printmaker's death and painfully recalled the "vainglorious parade of the Düsseldorf business, and its consequent bankruptcy" as an overly ambitious project that had torn at the financial fabric of the Greens and their associates (p. 446). Ross himself appears to have been affected, blam-

FIG. 25. *Valentine Green (English, 1739–1813), after Giulio Cesare Procaccini (Italian, 1574–1625).* The Holy Family, *1801, colored mezzotint with some handcoloring, 61.7 x 40.5 mm. London, British Museum (1937,0410.32). Photo © The Trustees of the British Museum.*

ing the Greens for inaccurately calculating the costs of such a large and complex collaborative enterprise. While much more archival work is needed to determine the details of the Greens' business and its collapse, it seems likely that Ross was referring to the entire cost of producing highly finished, painted copies, the kind that attracted the favorable attention of newspaper critics. What Green paid for the copies is unknown, but for comparison we can turn to Boydell in the 1770s, who gave his four draftsmen an extraordinary average of thirty pounds per drawing in preparation for the two-volume *Houghton Gallery* publication, which contained 129 numbered prints. Green, with his seventy-two painted copies, must have incurred far greater costs than did Boydell with the drawn copies.

The Greens' poor planning, if indeed that was the case, reminds us of other *Galeriewerk* publishers who experienced similar difficulties, namely Krahe and Heinecken. The Greens' situation, however, must have been exacerbated by the floundering economy in the final years of the eighteenth century. In his *English Print, 1688–1802* (1997), Timothy Clayton describes how the French Revolution and the

Napoleonic Wars in the 1790s hampered the English from exporting their prints, an activity that constituted a substantial portion of business for publishers such as Green and Boydell. Even the successful Boydell, whose stock appeared in English- and French-language catalogues, only narrowly avoided bankruptcy. In addition to the economic choke hold on the well-established international print trade, troubled partnerships between English and Continental printmakers sometimes proved fatal to ventures like that of the Greens. In fact, they suffered a serious setback with the downfall of their partner, Christian von Mechel (1737–1817), who also played a significant role in *La galerie électorale de Dusseldorff* in the 1770s.[14]

The trouble with the Greens must have started before 1795, when, according to a notice that appeared on 13 October 1795 in the *London Gazette*, Valentine and his son Rupert dissolved their partnership, with Rupert taking responsibility for the business and any debts (p. 1065). In fact, in 1796 Rupert's name alone appeared as publisher upon his father's reproduction of Jacob Jordaens's *Satyr and Peasant* (Munich, Alte Pinakothek). If these actions were somehow meant to distance Valentine from the business end of the Green enterprise, they failed to do so in the minds and pocketbooks of future creditors.

A most serious blow to the Greens' enterprise appears to have been the destruction of their exported stock in Düsseldorf. An early biography, to which Green responded in order to clarify some facts about his birthplace, describes the situation thusly:

> It is but too well known what have been the effects of the War in that part of Germany, and about the year 1798, when Düsseldorf became the scene of action. The siege of the city by the French, occasioned the removal and dispersion of the pictures; and the bombardment, which laid the castle and the gallery which adjoins it, in ruins, destroyed, together with a very considerable property belonging to Mr. Green and his colleagues. (*Monthly Mirror*, June 1809, p. 325)

The painful decline of the Greens dragged on between September 1798 and December 1808, according to at least seven notices published in the *London Gazette* about the bankruptcy. While some of Valentine's effects were sold from their former premises on 31 October 1798, this according to Joseph Farington's diary, the Commission of Bankrupt awarded against the Greens initially allowed them to complete certain prints and, it appears, to arrange for the publication of their stock with other publishers in a bid to recoup funds for creditors. Hence, in 1801 Francis Jukes's imprimatur appears on impressions of Green's *Holy Family* after the original by Giulio Cesare Procaccini, which had first been published in 1792 by Valentine and Rupert Green (fig. 25). The impression illustrated here seems to have followed Green's own practice of offering the public more expensive handcolored versions. Of course, it is possible that by 1801 Jukes and the other publishers actually owned some of Green's plates and were simply imitating his practice of coloring over weaker impressions.

Whatever strategy Green and his creditors might have adopted to salvage the business was bound to have failed given that the "smoky manner of Valentine Green and his contemporaries was superseded" by a shift in taste toward prints distinguished by their "brilliant execution and Characteristick imitation of the touch in the [original] Picture," according to Farington's diaries (24 January 1805).

FIG. 26. *Gilles Rousselet (French, 1610–86), after Nicolas Poussin (French, 1594–1665).* Eliezer and Rebekah, *1677, engraving, 42.3 x 62.9 cm. Los Angeles, Getty Research Institute.*

In other words, collectors came to appreciate prints that had been freely and aggressively scraped and burnished to imitate the effects of a painting's surface and that would, in the course of the following decades, come to characterize the romantic phase of the English mezzotint.

None of the attempts to save Green and to pay creditors succeeded. With the demise of Green's banker, the whole affair approached its sad ending. Two years after Rupert's untimely death in 1804, the *London Gazette* reported that a Commission of Bankrupt against the Greens would preside over the creditor's impending decision to sell their copperplates (2 December 1806, p. 1578). Finally, the painted copies exhibited at Spring Gardens, which were the last remnants of the "vainglorious parade of the Düsseldorf business," were sold in April and May 1807 by Henry J. and George Henry Robins, auctioneers in Covent Gardens. The modest auction results were most likely less than what Green paid to have the copies made in Düsseldorf.

The dispersal of Green's painted copies preceded by a few years the publication of the final volumes for the *Galerie de Florence et du Palais Pitti* in 1807 and the *Galerie du Palais royal* in 1808. These works were initiated just prior to the French Revolution, and in a way their success marked the end of the princely collection albums of the ancien régime. In fact, the quality of their reproductive prints and the text attached to them already pointed to the thoroughly utilitarian sensibility that characterized the forebearers of the modern museum catalogue, namely the eleven-volume *Galerie du musée Napoléon* (1801–28) and the twenty-one-volume *Annales du musée et de l'école moderne des beauxarts:*

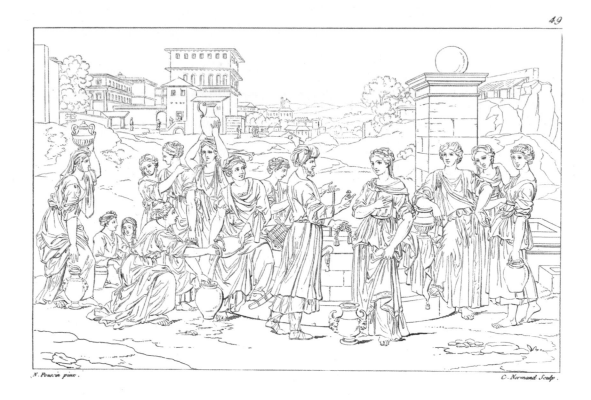

N. Poussin pinx. C. Normand sculp.

FIG. 27. *Charles Normand (French, 1765–1840), after Nicolas Poussin (French, 1594–1665).* Eliezer and Rebekah, *ca. 1800, etching, sheet: 12 x 18.7 cm, image: 9.1 x 14 cm. From Charles Paul Landon,* Annales du musée et de l'école moderne des beaux-arts *(Paris: C. Landon, 1800), coll. 1, vol. 1, pl. 49. Los Angeles, Getty Research Institute.*

Recueil de gravures au trait . . . (ca. 1800–1824). The shift in interest toward the Musée du Louvre, recently bloated by the revolutionary government's official sequestration of masterpieces and Napoleon's pan-European looting, was driven by nationalistic and pedagogic imperatives that inscribed citizens into the circle of collection ownership and to a certain extent pulled their attention from aristocratic collections (many of which had been dispersed) and, perhaps, *Galeriewerke.* It is tempting to wonder if this shift was accompanied by a practical sensibility, one that defined the reproductive print as nothing more than a mere graphic copy of an infinitely greater original. A symptom of such a shift, that only more research can adequately define, might be the typical outline etching in the *Annales,* an extreme case of absolute utilitarianism, which was to become more common in the modern era than it had been previously—that is, when critics and collectors expected much of printmakers such as Gilles Rousselet, who in his work for Louis XIV's seventeenth-century *Galeriewerk* employed the complex *gravure rangée* (literally, "arranged engraving"), presenting the print as both a translation and a work of art in its own right (figs. 26, 27). Over a century later, the illustrations in the *Galerie du musée Napoléon* and the *Annales* functioned simply as pale reminders of original works of art, constituting only a part of these multivolume publications. The quality of their illustrations portended the eventual devaluation of the reproductive print as a work of art and, by extension, the end of the *Galeriewerk* tradition.

ENDNOTES

1. The *Theatrum Pictorium* was published in five editions: 1660, 1673, 1684, ca. 1692, and 1755. Ernst Vegelin van Claerbergen, ed., *David Teniers and the Theatre of Painting* (London: Courtauld Institute of Art Gallery in association with Paul Holberton Publishing, 2006).

2. It has since been reattributed to Titian's workshop, after the master's painting in the National Gallery of Scotland, Edinburgh.

3. Martin Schuster, "Remarks on the Development of the *Recueil d'estampes d'après les plus célèbres tableaux de la Galerie royale de Dresde* by Carl Heinrich von Heineken 1753 and 1757," in Cordélia Hattori, Estelle Leutrat, and Véronique Meyer, eds., *À l'origine du livre d'art: Les recueils d'estampes comme enterprise éditoriale en Europe (XVIe–XVIIIe siècles)* (Milan: Silvana, 2010), 153–67; and Virginie Spenlé, "Representation princière et connaissance des arts: Les recueils de gravures d'après les collections de Dresde au XVIIIe siècle," in Cordélia Hattori, Estelle Leutrat, and Véronique Meyer, eds., *À l'origine du livre d'art: Les recueils d'estampes comme enterprise éditoriale en Europe (XVIe–XVIIIe siècles)* (Milan: Silvana, 2010), 169–77.

4. Translated by the author from Jan Blanc's French translation of Samuel von Hoogstraten, *Introduction à la haute école de l'art de la peinture*, trans. Jan Blanc (Geneva: Droz, 2006), 323.

5. Christian Michel, "Les débats sur la notion de graveur/traducteur en France au XVIIIe siècle," in Francois Fossier, ed., *Delineavit et Sculpsit: Mélanges offerts à Marie-Félicie Perez-Pivot* (Lyon: Presses universitaires de Lyon, 2003), 151–61.

6. Dieter Graf, *Master Drawings of the Roman Baroque from the Kunstmuseum Düsseldorf: A Selection from the Lambert Krahe Collection*, exh. cat. (London: Victoria & Albert Museum, 1973); and Heindrun Rosenberg, "'. . . mindeste Connexion nicht habend . . .': Zu den Galeriepublikationsprojekten von Wilhelm Lambert Krahe und Nicolas de Pigage," in *Schloss Benrath und sein Baumeister Nicolas de Pigage, 1723–1796*, exh. cat. (Düsseldorf: Stadtmuseum Düsseldorf, 1996), 119–35.

7. Rosenberg, "'. . . mindeste Connexion nicht habend . . . ,'" 122.

8. For a mezzotint, a copperplate is prepared by employing a fine or coarse rocker to ground, or roughen, the plate's surface, which if printed will result in a sheet that is uniformly dark. The engraver then uses a burnisher and scraper to create varying degrees of roughness in order to achieve a variety of lighter tonal values.

9. Timothy Clayton, *The English Print, 1688–1802* (New Haven: Yale Univ. Press, 1997), 269; and Martin Myrone, "Boydell, John, Engravers (Act. 1760–1804)," in *Oxford Dictionary of National Biography*, online ed., ed. Lawrence Goldman (Oxford: Oxford Univ. Press). According to *Allgemeines Künstler-Lexikon* (Berlin: de Gruyter, 2011), 5, only Johann went to London in the 1760s.

10. Rosenberg, "'. . . mindeste Connexion nicht habend . . . ,'" 130.

11. On Valentine Green, see "Memoirs of Mr. Valentine Green," *Monthly Mirror* (June 1809): 323–25; James Ross, "Mr. V. Green," *Gentleman's Magazine* 114 (November 1813): 446; Alfred Whitman, *Valentine Green* (London: A. H. Bullen, 1902); Hans W. Singer, "Some Mezzotints by MacArdell and Valentine Green," *Burlington Magazine* 11, no. 51 (1907): 182–84, 187–88; and Clayton, *The English Print*, passim.

12. Clayton, *The English Print*, 261–82; and Antony Griffiths and Frances Carey, *German Printmaking in the Age of Goethe* (London: British Museum, 1994), 20.

13. Sven H. A. Bruntjen, *John Boydell, 1719–1804: A Study of Art Patronage and Publishing in Georgian London* (New York: Garland, 1985).

14. Clayton, *The English Print*, 281; and Antony Griffiths, "The Contract for *The Grand Attack on Valenciennes*," *Print Quarterly* 20, no. 4 (2003): 374–79.

APPENDIX
FAILED DÜSSELDORF *GALERIEWERKE*

Abbreviations: GRI = Getty Research Institute, Los Angeles; BM= British Museum, London; HAUM= Herzog Anton Ulrich-Museum, Braunschweig; KSKD = Kupferstichkabinett, Staatliche Kunstsammlungen Dresden; KSMB = Kupferstichkabinett, Staatliche Museen zu Berlin; VAM = Victoria and Albert Museum, London; VC = Kupferstichkabinett, Veste Coburg, Coburg. SK = Städelsches Kunstinstitut, Frankfurt am Main.

LAMBERT KRAHE'S DÜSSELDORF PROJECT

Printmaker:
Johann Elias Haid (German, 1737–1809)

1. *Frontispiece*, after Adriaen van der Werff
(Dutch, 1659–1722).
Mezzotint, ca. 1770.
Le Blanc II, 331, 16.
HAUM.

2. *Annunciation*, after Adriaen van der Werff
(Dutch, 1659–1722).
Mezzotint, ca. 1770.
Le Blanc II, 331, 3. (Pigage 221).
BM; HAUM.

3. *Nativity*, after Adriaen van der Werff
(Dutch, 1659–1722).
Mezzotint, ca. 1770.
Le Blanc II, 331, 4. (Pigage 223).
HAUM.

4. *Visitation*, after Adriaen van der Werff
(Dutch, 1659–1722).
Mezzotint, ca. 1770.
(Pigage, 222).
HAUM.

VALENTINE GREEN'S DÜSSELDORF PROJECT

Valentine and Rupert Green had planned to publish one hundred prints after paintings in Düsseldorf. The prints on this list appear in Valentine and Rupert Green's catalogues published for the exhibition they organized at Spring Gardens from May through June 1793. The prints with catalogue numbers 109 through 123, from the Descriptive Catalogue, *were most certainly on display; two of the fourteen images were "unfinished proofs." The same prints appear on pages 15 and 16, along with eleven other images the Greens intended to publish. These prints are marked by subscription numbers 1 through 25. Only some of those prints were published. The list below should be considered a work in progress.*

Printmakers:
Lawrence Jean Cosse (English, ca. 1758–1838?)
John Eginton (English, active 1775–1804)
Valentine Green (English, 1739–1813)
Carl Ernst Christoph Hess (German, 1755–1828)
Ernst Carl Gottlieb Thelott (German, 1760–1834/9)

1. Valentine Green, *Christ among the Doctors*,
after Adriaen van der Werff (Dutch, 1659–1722).
Mezzotint, published by Valentine and Rupert Green,
3 June 1791.
Whitman, 263; *Descriptive Catalogue* (1793), 114. (Pigage, 225).
BM; KSMB.

2. Valentine Green, *Castor and Pollux*,
after Peter Paul Rubens (Flemish, 1577–1640).
Mezzotint, published by Valentine and Rupert Green,
3 June 1791.
Whitman, 277; *Descriptive Catalogue* (1793), 118. (Pigage, 244).
KSMB.

3. Valentine Green, *The Crucifixion*,
after Adriaen van der Werff (Dutch, 1659–1722).
Mezzotint, published by Valentine and Rupert Green,
2 January 1792; and 1 July 1797.
Whitman, 264; *Descriptive Catalogue* (1793), 117. (Pigage, 231).
GRI; BM.

4. Valentine Green, *Jupiter and Antiope*,
after a painting formerly attributed to Anthony van Dyck
(Flemish, 1599–1641), now attributed to Thomas Willeboirts
(Flemish, 1614–54).
Mezzotint, published by Valentine and Rupert Green,
2 January 1792.
Whitman, 278; *Descriptive Catalogue* (1793), 113. (Pigage, 22).

5. Valentine Green, *Christ and the Four Penitents*,
after Peter Paul Rubens (Flemish, 1577–1640).
Mezzotint, published by Valentine and Rupert Green,
31 May 1792.
Whitman, 266; *Descriptive Catalogue* (1793), 112. (Pigage, 274).
GRI; BM; KSMB.

6. Valentine Green, *The Murder of the Innocents*,
after Annibale Carracci (Italian, 1560–1609).
Mezzotint, published by Valentine and Rupert Green,
31 May 1792; and 1 July 1797; by R. Crib, 1801.
Whitman, 265; Singer, p. 188; *Descriptive Catalogue* (1793),
121. (Pigage, 114).
BM; KSMB; VAM.

7. Valentine Green, *The Holy Family*,
after Giulio Cesare Procaccini (Italian, 1574–1625).
Mezzotint, published by Valentine and Rupert Green,
1 September 1792; by F. Jukes, 2 March 1801.
Whitman, 267; *Descriptive Catalogue* (1793), 120. (Pigage, 140).
BM; KSMB.

8. Carl Ernst Christoph Hess, *The Assumption of the Virgin*,
after Guido Reni (Italian, 1575–1642).
Stipple, published by Valentine and Rupert Green,
1 September 1792.
Nagler, 3; *Descriptive Catalogue* (1793), 115 (and the same subject
in color, 116); Reber, 1170; Apell, 8; Leblanc, 13. (Pigage, 201).
KSKD.

9. Valentine Green, *Saint John in the Wilderness*,
after Raphael (Italian, 1483–1520), now attributed to Daniele
da Volterra (Italian, ca. 1509–66).
Mezzotint, published by Valentine and Rupert Green,
1 November 1792.
Whitman, 268; *Descriptive Catalogue* (1793), 119. (Pigage, 165).
GRI; BM.

10. Valentine Green, *The Temptation in the Desert*,
after Luca Giordano (Neapolitan, 1634–1705).
Mezzotint, published by Valentine and Rupert Green,
1 November 1792.
Whitman, 274; Singer, p. 188; *Descriptive Catalogue* (1793), 111.
(Pigage, 153).
BM.

11. Ernst Carl Gottlieb Thelott, *A Village Festival*,
after David Teniers the Younger (Flemish, 1610–90).
Etching and engraving, 1 March 1793.
Nagler, 17; *Descriptive Catalogue* (1793), 110; Reber, 905.
(Pigage, 47).
SK.

12. Lawrence Jean Cosse, *The Holy Family*,
after Andrea del Sarto (Italian, 1486–1530).
Stipple, published by Valentine and Rupert Green,
1 August 1793.
Descriptive Catalogue (1793), 122; Reber, 166; Le Blanc I.
(Pigage, 121).
KSKD.

13. Valentine Green, *The Entombing of Christ*,
after Lodovico Carracci (Italian, 1555–1619).
Mezzotint, published by Valentine and Rupert Green,
1 November 1793.
Whitman, 270; *Descriptive Catalogue* (1793), p. 16, no. 19.
(Pigage, 173).
BM.

14. Valentine Green, *Samson Betrayed by Delilah*,
after Peter Paul Rubens (Flemish, 1577–1640).
Mezzotint, published by Valentine and Rupert Green,
1 November 1793; by J. Daniell & Co., 25 March 1799.
Whitman, 269; *Descriptive Catalogue* (1793), 109 (unfinished
proof). (Pigage, 269).
GRI; BM.

15. Valentine Green, *The Visitation*,
after Adriaen van der Werff (Dutch, 1659–1722).
Mezzotint, published by Valentine and Rupert Green,
1 March 1794.
Singer, p. 188; *Descriptive Catalogue* (1793), p. 16, no. 21.
(Pigage, 222).
GRI; KSMB.

16. Valentine Green, *The Virgin, with the Infant Jesus, and
Saint John*, after Anthony van Dyck (Flemish, 1599–1641).
Mezzotint, published by Valentine and Rupert Green,
21 May 1794.
Descriptive Catalogue (1793), p. 16, no. 24. (Pigage, 61).
KSMB; VC.

17. Valentine Green, *The Ascension*,
after Adriaen van der Werff (Dutch, 1659–1722).
Mezzotint, published by Valentine and Rupert Green,
1 March 1794.
Nagler, 21; Singer, p. 188; *Descriptive Catalogue* (1793), p. 16,
no. 22. (Pigage, 234).
GRI.

18. John Eginton, *Susanna and the Two Elders*,
after Domenichino (Italian, 1581–1641).
Stipple and etching, published by Valentine and Rupert Green,
1 January 1795.
Descriptive Catalogue (1793), 123 (unfinished proof). (Pigage, 113).
BM; KSMB.

19. Valentine Green, *Satyr and Peasant*,
after Jacob Jordaens (Flemish, 1593–1678).
Mezzotint, published by Rupert Green, 1 January 1796.
Whitman, 275; *Descriptive Catalogue* (1793), p. 116, no. 23.
Singer, p. 188. (Pigage, 208).
GRI; BM.

20. Carl Ernst Christoph Hess, *Rubens and His First Wife*,
after Peter Paul Rubens (Flemish, 1577–1640).
Stipple and engraving, published by Rupert Green,
1 January 1796.
Nagler, 5; Schneevoogt, 164.86; Apell, 20;
Descriptive Catalogue (1793), p. 16, no. 15. (Pigage, 286).
BM; KSMB.

21. Carl Ernst Christoph Hess, *The Quack Doctor*,
after Gerrit Dou (Dutch, 1613–75).
Etching and engraving, published by Valentine and Rupert
Green, 21 May 1797.
Nagler, 4; Hollstein, 51; *Descriptive Catalogue* (1793), p. 16, no. 18.
(Pigage, 63).
BM.

SELECTED BIBLIOGRAPHY

Apell, Aloys. *Handbuch für Kupferstichsammler; oder, Lexikon der vorzuglichsten Kupferstecher des 19 Jahrhunderts.* Leipzig: Alexander Danz, 1880.

Bähr, Astrid. *Repräsentieren, Bewahren, Belehren: Galeriewerke (1660–1800), Von der Darstellung herrschaftlicher Gemäldesammlungen zum populären Bildband.* Hildesheim: Georg Olms, 2009.

Basan, Pierre-François. *Recueil d'estampes gravées d'après les tableaux du cabinet de Monseigneur le duc de Choiseul.* Paris: Chez l'Auteur, 1771.

Baumgärtel, Bettina, ed. *Himmlisch, Herrlich, Höfisch: Peter Paul Rubens, Johann Wilhelm von der Pfalz, Anna Maria Luisa de' Medici.* Düsseldorf: E. A. Seemann, 2008.

Baumstark, Reinhold, ed. *Kurfürst Johann Wilhelms Bilder.* 2 vols. Munich: Hirmer, 2009.

Bonafons, Louis-Abel de [l'abbé de Fontenai]. *Galerie du Palais royal: Gravée d'après les tableaux des differentes ecoles qui la composent: Avec un abrégé de la vie des peintres & une description historique de chaque tableau.* Paris: J. Couché; Paris: J. Bouillard, 1786–1808.

Borea, Evelina. "Per i primi cataloghi figurati delle raccolte d'arte nel Settecento." In Caterina Bon Valsassina, ed., *Il segno che dipinge,* 75–96. Bologna: Pendragon, 2002.

Boydell, John. *A Catalogue of Prints, Published by John Boydell, Engraver in Cheapside, London.* London: Boydell, 1773.

Brown, Jonathan. *Kings & Connoisseurs: Collecting Art in Seventeenth-Century Europe.* New Haven: Yale Univ. Press, 1995.

Bruntjen, Sven H. A. *John Boydell, 1719–1804: A Study of Art Patronage and Publishing in Georgian London.* New York: Garland, 1985.

Budde, Illa. *Beschreibender Katalog Der Handzeichnungen in der Staatlichen Kunstakademie Düsseldorf.* Düsseldorf: Druck & Verlag von L. Schwann, 1930.

Claerbergen, Ernst Vegelin van, ed. *David Teniers and the Theatre of Painting.* London: Courtauld Institute of Art Gallery in association with Paul Holberton Publishing, 2006.

Clayton, Timothy. *The English Print, 1688–1802.* New Haven: Yale Univ. Press, 1997.

Colins, François-Louis. *Catalogue des tableaux qui se trouvent dans les galleries du Palais de S. A. S. E. Palatine, a Dusseldorff.* n.p.: n.p., ca. 1755.

Crozat, Pierre. *Recueil d'estampes d'après les plus beaux tableaux et d'après les plus beaux desseins qui sont en France dans le cabinet du Roy, dans celuy de Monseigneur le duc d'Orléans, & dans d'autres cabinets* 2 vols. Paris: De l'Imprimerie royale, 1729–42. Known as the Recueil Crozat.

Descamps, Jean-Baptiste. *Lu vie des peintres flamands, allemands et hollandois.* Paris: C. A. Jombert, 1753–64.

Díaz Padrón, Matías. *David Teniers, Jan Brueghel y los gabinetes de pinturas.* Madrid: Museo del Prado, 1992.

Dresde; ou, Le rêve des princes: La galerie de peintures au XVIIIe siècle. Exh. cat. Dijon: Musée de beaux-arts de Dijon, 2001.

Dresdener Kunstblätter 1 (2009). Contains contributions by Mathias Dämmig, Gernot Klatte, Esther Münzberg, Grit Mußack, Marc Rohrmüller, Martin Schuster, Virginie Spenlé, and Tristan Weddigen.

Emeric-David, Toussaint-Bernard. *Discours historique sur la gravure en taille-douce et sur la gravure en bois.* Paris: H. Agasse, 1808.

Fimpeler-Philippen, Annette, and Sonja Schürmann. *Das Schloss in Düsseldorf.* Düsseldorf: Droste, 1999.

Frédou de la Bretonnière, Jean-Victor. *Observations raisonnées sur l'art de la peinture appliquées, sur les tableaux de la gallerie électorale de Dusseldorff* Düsseldorf: Zehnpfennig, 1776.

Gaehtgens, Barbara. *Adriaen van der Werff, 1659–1722.* Munich: Deutscher Kunstverlag, 1987.

Garlick, Kenneth, Angus Macintyre, and Kathryn Cave, eds. *The Diary of Joseph Farington.* 16 vols. New Haven: Yale Univ. Press, 1978–84.

The Glory of Baroque Dresden: The State Art Collections Dresden. Exh. cat. Jackson, Miss.: Mississippi Arts Pavilion, 2004.

Graf, Dieter. *Master Drawings of the Roman Baroque from the Kunstmuseum Düsseldorf: A Selection from the Lambert Krahe Collection.* Exh. cat. London: Victoria & Albert Museum, 1973.

Grand Duke's Cabinet. Florence, ca. 1695–1720. Getty Research Institute, Los Angeles, 2002.PR.8.

Green, Valentine, and Rupert Green. *A Catalogue of Pictures from the Dusseldorf Gallery, Exhibited at the Great Room, Spring Gardens, London, by Messrs. V. and R. Green.* London: H. Reynell, 1793.

Green, Valentine, and Rupert Green. *A Descriptive Catalogue of Pictures from the Dusseldorf Gallery, Exhibited at the Great Room, Spring Gardens, London, by Messrs. V. and R. Green.* London: H. Reynell, 1793.

Griener, Pascal. *La république de l'œil: L'expérience de l'art au siècle des Lumières.* Paris: Odile Jacob, 2010.

Griffiths, Antony. "The Contract for The Grand Attack on Valenciennes." *Print Quarterly* 20, no. 4 (2003): 374–79.

Griffiths, Antony, and Frances Carey. *German Printmaking in the Age of Goethe.* London: British Museum, 1994.

Haag, Sabine, Gudrun Swoboda, Elke Oberthaler, and Robert Wald. *Die Galerie Kaiser Karls VI. in Wien: Solimenas Widmungsbild und Storffers Inventar (1720–1733).* Vienna: Kunsthistorisches Museum, 2010.

Haskell, Francis. *The Painful Birth of the Art Book.* New York: Thames & Hudson, 1987.

Heinecken, Karl Heinrich von. *Idée générale d'une collection complette d'estampes. Avec une dissertation sur l'origine de la gravure & sur les premiers livres d'images.* Leipzig, & Vienna: Jean Paul Kraus, 1771.

Heinecken, Karl Heinrich von. *Recueil d'estampes d'apres les plus celebres tableaux de la Galerie royale de Dresde....* 2 vols. Dresden: Chrêtien Hagenmüller, 1753–57.

Hollstein, F. W. H. *Dutch and Flemish Etchings, Engravings and Woodcuts ca. 1450–1700.* 72 vols. Amsterdam: M. Hertzberger, 1949–2010.

Hoogstraten, Samuel van. *Introduction à la haute école de l'art de la peinture.* Translated by Jan Blanc. Geneva: Droz, 2006.

Karsch, Gerhard Joseph. *Ausfuehrliche und gruendliche Specification derer vortrefflichen und unschaetzbaren Gemaehlden....* Düsseldorf: Stahl, 1719.

Ketelsen, Thomas. *Künstlerviten, Inventare, Kataloge: Drei Studien zur Geschichte der kunsthistorischen Praxis.* Ammersbek bei Hamburg: Verlag an der Lottbek, Peter Jensen, 1988.

Klapheck, Richard. *Die Kunstsammlungen Der Staatlichen Kunstakademie zu Düsseldorf.* Düsseldorf: Druck & Verlag von Mathias Strucken, 1928.

Kleiner, Salomon. *Representation au naturel des chateaux de Weissenstein au dessus de Pommersfeld, et de celui de Geubach appartenans a la maison des comtes de Schönborn....* Augsburg: Ieremie Wolff, 1728.

Klinge, Margret. "David Teniers and the Theatre of Painting." In Ernst Vegelin van Claerbergen, ed., *David Teniers and the Theatre of Painting,* 10–39. London: Courtauld Institute of Art Gallery in association with Paul Holberton Publishing, 2006.

Koch, Sabine. "Die Düsseldorfer Gemäldegalerie." In Bénédicte Savoy, ed., *Tempel der Kunst: Die Geburt des öffentlichen Museums in Deutschland, 1701–1815,* 87–115. Mainz: Verlag Philipp von Zabern, 2006.

Küffner, Hatto, and Edmund Spohr. *Burg und Schloss Düsseldorf: Baugeschichte einer Residenz.* Jülich: Jülicher Geschichtsverein 1923 e.V., 1999.

Landon, Charles Paul. *Annales du musée et de l'école moderne des beaux-arts.* Coll. 1, vol. 1. Paris: C. Landon, 1800.

Le Blanc, Charles. *Manuel de l'amateur d'estampe.* 4 vols. Paris: E. Bouillon, 1854–90.

Levesque, Pierre Charles, Charles Joseph Panckoucke, Clément Plomteux, and Henri Agasse. *Encyclopédie méthodique: Dédiés et présentés a Monsieur Vidaud de la Tour, conseiller d'État, et directeur de la librairie. Beaux-arts.* Paris: Panckoucke, libraire, hôtel de Thou, rue des Poitevins, 1788.

Logan, Anne-Marie S. *The "Cabinet" of the Brothers Gerard and Jan Reynst.* New York: North-Holland Publishing, 1979.

Marchesano, Louis. "The *Impostures Innocentes*: Bernard Picart's Defense of the Professional Engraver." In Lynn Hunt, Margaret Jacob, and Wijnand Mijnhardt, eds., *Bernard Picart and the First Global Vision of Religion*, 105–35. Los Angeles: Getty Publications, 2010.

Mauer, Benedikt, ed. *Barocke Herrschaft am Rhein um 1700: Kurfürst Johann Wilhelm II und seine Zeit*. Düsseldorf: Droste, 2009.

McClellan, Andrew. *Inventing the Louvre: Art, Politics, and the Origins of the Modern Museum in Eighteenth Century Paris*. New York: Cambridge Univ. Press, 1994.

McClellan, Andrew. *The Art Museum: From Boullée to Bilbao*. Berkeley: Univ. of California Press, 2008.

Mechel, Christian von. *Verzeichniss der Gemälde der Kaiserlich Königlichen Bilder Gallerie in Wien*. Vienna: Christian von Mechel, 1783.

Mechel, Christian von, and Nicolas de Pigage. *La galerie électorale de Dusseldorff; ou, Catalogue raisonné de ses tableaux....* 2 vols. Basel: Christian von Mechel, 1778.

Mechel, Christian von, and Nicolas de Pigage. *La galerie électorale de Dusseldorff; ou, Catalogue raisonné et figuré de ses tableaux....* Brussels: J. B. Jorez, 1781.

Mechel, Christian von, and Nicolas de Pigage. *La galerie électorale de Dusseldorff: Die Gemäldegalerie des Kurfürsten Johann Wilhelm von der Pfalz in Düsseldorf*. Edited by Reinhold Baumstark. Basel: Christian von Mechel, 1778; reprint, Munich: Hirmer, 2009.

Meijers, Debora J. *Kunst als Natur, Die Habsburger Gemäldegalerie in Wien um 1780*. Schriften des Kunsthistorischen Museums 2. Vienna: Skira, 1995.

"Memoirs of Mr. Valentine Green." *Monthly Mirror* (June 1809): 323–25.

Michel, Christian. *Charles-Nicolas Cochin et l'art des lumières*. Rome: École français de Rome, 1993.

Michel, Christian. "Les débats sur la notion de graveur/traducteur en France au XVIIIe siècle." In Francois Fossier, ed., *Delineavit et Sculpsit: Mélanges offerts à Marie-Félicie Perez-Pivot*, 151–61. Lyon: Presses universitaires de Lyon, 2003.

Myrone, Martin. "Boydell, John, Engravers (act. 1760–1804)." In *Oxford Dictionary of National Biography*. Edited by Lawrence Goldman. Oxford: Oxford Univ. Press, 2004–. Accessed 11 March 2011. http://www.oxforddnb.com/view/article/65008.

Nagler, Georg Kaspar. *Neues allgemeines Künstler-Lexikon*. 22 vols. Munich: E. A. Fleischmann, 1835–52.

Neergaard, T. C. Bruun. "Observations on the Gallery of Dusseldorf, in a *Letter to a Friend*." *Monthly Magazine; or, British Register* 25, no. 167, pt. 1 (1 February 1808): 12–16.

[Notice.] *London Gazette*, 13 October 1795, 1065; 25 July 1798, 718; 11 September 1798, 871; 20 October 1798, 1002; 2 December 1806, 1578; 5 July 1808, 957; 1 November 1808, 1501; 3 December 1808, 1653.

Oesterreich, Matthias. *Beschreibung der Königlichen Bildergalleri und des Kabinets im Sans-Souci*. Edited by Burkhardt Göres. Potsdam: Christian Friedrich Voß, 1764; reprint, Berlin-Brandenburg: Generaldirektion der Stiftung Preussische Schlösser & Gärten, 1996.

Press cuttings, 1793, vol. 3, 649, 658. British Eighteenth-Century Provenance Index Sales Files. Getty Provenance Index Databases. J. Paul Getty Trust.

Prümm, Gustav. Ein *"Gewinn fürs ganze Leben": Die Düsseldorfer Gemäldegalerie des Kurfürsten Johann Wilhelm von der Pfalz*. Norderstedt: n.p., 2009.

Reber, Franz V. *Catalogue of the Paintings in the Old Pinakothek, Munich*. Translated by Joseph Thacher Clarke. Munich: Knorr & Hirth, 1885.

Reynolds, Joshua. *A Journey to Flanders and Holland, London 1781*. Edited by Harry Mount. Cambridge: Cambridge Univ. Press, 1996.

Rosenberg, Heidrun. "'…mindeste Connexion nicht habend….' Zu den Galeriepublikationsprojekten von Wilhelm Lambert Krahe und Nicolas de Pigage." In *Schloss Benrath und sein Baumeister Nicolas de Pigage, 1723–1796*, 119–35. Düsseldorf: Wienand, 1996.

Ross, James. "Mr. V. Green." *Gentleman's Magazine* 114 (November 1813): 446.

Savoy, Bénédicte, ed. *Tempel der Kunst: Die Geburt des öffentlichen Museums in Deutschland, 1701–1815.* Mainz: Verlag Philipp von Zabern, 2006.

Schaarschmidt, Friedrich. *Zur Geschichte der Düsseldorfer Kunst insbesondere im XIX. Jahrhundert.* Düsseldorf: Kunstverein für die Rheinlande & Westfalen, 1902.

Schneevoogt, C. G. Voorhelm. *Catalogue des estampes gravées d'après P. P. Rubens.* Haarlem: Les hériters Loosjes, 1873.

Schuster, Martin. "Remarks on the Development of the Recueil d'Estampes d'après les plus célèbres Tableaux de la Galerie Royale de Dresde by Carl Heinrich von Heineken 1753 and 1757." In Cordélia Hattori, Estelle Leutrat, and Véronique Meyer, eds., *À l'origine du livre d'art: Les recueils d'estampes comme enterprise éditoriale en Europe (XVIe–XVIIIe siècles),* 153–67. Milan: Silvana, 2010.

Singer, Hans W. "Some Mezzotints by MacArdell and Valentine Green." *Burlington Magazine* 11, no. 51 (1907): 182–84, 187–88.

Sonnenburg, Hubertus von. *Raphael in der Alten Pinakothek: Geschichte und Wiederherstellung des ersten Raphael-Gemäldes in Deutschland und der von König Ludwig I. erworbenen Madonnenbilder....* Exh. cat. Munich: Prestel, 1983.

Spenlé, Virginie. "Representation princière et connaissance des arts: Les recueils de gravures d'après les collections de Dresde au XVIIIe siècle." In Cordélia Hattori, Estelle Leutrat, and Véronique Meyer, eds., *À l'origine du livre d'art: Les recueils d'estampes comme enterprise éditoriale en Europe (XVIe–XVIIIe siècles),* 169–77. Milan: Silvana, 2010.

Stampart, Frans van, and Anton Joseph von Prenner. *Prodromus; seu, Praembulare Lumen Reserati Protentosae Magnificentiae Theatri quo Omnia ad Aulam Caesaream in Augustissimae Suae Caesareae, & Regiae Catholicae Majestatis Nostri Gloriosissime Regnantis Monarchae Caroli VI.* Vienna: Typis Joannis Petri Van Ghelen, 1735.

Swoboda, Gudrun. *Die Wege der Bilder: Eine Geschichte der kaiserlichen Gemäldesammlungen von 1600 bis 1800.* Vienna: Christian Brandtstätter, 2008.

Teniers, David, the Younger. *Theatrum Pictorium...* Brussels: Sumptibus auctoris [David Teniers]; Antwerp: Exstant apud Henricum Aertssens typographum, 1660.

Teniers, David, the Younger. *Theatrvm Pictorivm: In quo Exhibentur Ipsius Manu Delineatæ, Eiusque Curâ in Æs Incise Picturæ, Archetipæ Italicæ, Quas Ipse Ser. Mus Archdux in Pinacothecam Suam Bruxellis Collegit.* Antwerp: Apud Iacobum Peeters, 1684.

Tipton, Susan. "'La passion mia per la pittura': Die Sammlungen des Kurfürsten Johann Wilhelm von der Pfalz (1658–1716) in Düsseldorf im Spiegel seiner Korrespondenz." *Münchner Jahrbuch der bildenden Kunst,* 3rd ser., 57 (2006): 71–332.

Vermeulen, Ingrid R. *Picturing Art History: The Rise of the Illustrated History of Art in the Eighteenth Century.* Amsterdam: Amsterdam Univ. Press, 2010.

Waterfield, Giles. "Teniers's *Theatrum Pictorium*: Its Genesis and Its Influence." In Ernst Vegelin van Claerbergen, ed., *David Teniers and the Theatre of Painting,* 40–57. London: Courtauld Institute of Art Gallery in association with Paul Holberton Publishing, 2006.

Wegner, Wolfgang. *Kurfürst Carl Theodor von der Pfalz als Kunstsammler: Zur Entstehung und Gründungsgeschichte des Mannheimer Kupferstich–und Zeichnungskabinetts....* Mannheim: Gesellschaft der Freunde Mannheims & der Ehemaligen Kurpfalz, Mannheimer Altertumsverein von 1859, 1960.

Whitman, Alfred. *Valentine Green.* London: A. H. Bullen, 1902.

Wicar, Jean Baptiste Joseph, Antoine Mongez, and M. Lacombe. *Tableaux, statues, bas-reliefs et camées de la Galerie de Florence et du Palais Pitti....* 4 vols. Paris: Chez Lacombe, 1789–1807.

Wieczorek, Alfried, Hansjörg Probst, and Wieland Koenig, eds. *Lebenslust und Frömmigkeit: Kurfürst Carl Theodor (1724–1790) zwischen Barock und Aufklärung.* 2 vols. Exh. cat. Regensburg: Verlag Friedrich Pustet, 1999.

Wüthrich, Lukas Heinrich. *Das Oeuvre des Kupferstechers Christian von Mechel: Vollständiges Verzeichnis der von ihm geschaffenen und verlegten grafischen Arbeiten.* 2 vols. Basel: Helbing & Lichtenhahn, 1959.